PAUL SCHAMBROOM

PAUL SHAMBROOM PICTURING POWER

WEISMAN ART MUSEUM
UNIVERSITY OF MINNESOTA
MINNEAPOLIS

PUBLISHED BY WEISMAN ART MUSEUM
University of Minnesota
333 East River Road
Minneapolis, MN 55455
www.weisman.umn.edu

**DISTRIBUTED WORLDWIDE BY D.A.P./
DISTRIBUTED ART PUBLISHERS**
155 Sixth Avenue, 2nd Floor
New York, NY 10013
telephone (212) 627-1999; fax (212) 627-9484
dap@dapinc.com

NATIONAL
ENDOWMENT
FOR THE ARTS
A great nation
deserves great art.

This project was supported in part by an award from the National
Endowment for the Arts, which believes that a great nation
deserves great art.

Significant support for the exhibition and this book was provided
by The Andy Warhol Foundation for the Visual Arts.

EDITOR
Laura Westlund, Minneapolis

DESIGNERS
Matthew Rezac and Andrew Blauvelt, Minneapolis

Printed and bound in Belgium by Die Keure

**A CATALOGING-IN-PUBLICATION RECORD FOR THIS BOOK
IS AVAILABLE FROM THE LIBRARY OF CONGRESS.**

ISBN: 978-1-933045-75-7
ISBN-10: 1-933045-75-2

EXHIBITION ITINERARY
February 8 – April 20, 2008
Weisman Art Museum, University of Minnesota
Minneapolis, Minnesota

May 10 – September 14, 2008
Columbus Art Museum, Columbus, Ohio

October 3 – November 22, 2008
Atlanta Center for Contemporary Art, Atlanta, Georgia

January 22 – April 6, 2009
University Art Museum, California State University
Long Beach, California

CONTENTS

ACKNOWLEDG-
MENTS

The exhibition and catalogue Paul Shambroom: Picturing Power could not have happened without a number of people and institutions who contributed, supported, or participated in the project. The curators wish to recognize these efforts, knowing full well we cannot thank each person enough.

First and foremost, we are deeply indebted to Paul Shambroom. His tireless conversing, contributing, and editing of ideas, his involvement in the production of the book and in the exhibition, and his photographs were all vital to this endeavor. We could not have accomplished this without him and his generosity of time and spirit. We are truly grateful.

We wholeheartedly thank The Andy Warhol Foundation for the Visual Arts for its early support. Its belief in and commitment to this review of Shambroom's work was valuable beyond dollars and cents. We also thank the National Endowment for the Arts for its generosity. Without these key funders, Paul Shambroom: Picturing Power would not have been possible.

We extend thanks to the other contributors to this book. When Stuart Horodner arrived in Atlanta as the new curator of the Atlanta Contemporary Art Center, he not only agreed to maintain that institution's commitment to this project but he became personally involved, offering to conduct an interview with Shambroom. His thoughtful discussion with the artist was well researched and in its surprising turns presents fresh insight into Shambroom and his work. We are also indebted to Dick Hebdige, who added his considerable skill in reading artistic and cultural signs, making the book even richer.

Many members of the Weisman Art Museum staff were essential to the production of the book and the exhibition. WAM director Lyndel King embraced the scope and spirit of Paul Shambroom: Picturing Power from its very beginning; her unfaltering support has been instrumental and most appreciated. Jackie Starbird, curatorial assistant, is to be thanked and commended for being the glue that held the project together at every twist and turn. She contributed her well-honed production skills and her uncanny sense of organization to this multiregional enterprise, for which we are deeply grateful. Weisman intern Nicole Wankel deserves credit and our gratitude for her invaluable support in handling the rights and reproductions for the book and for capably managing every assignment sent her way. Former WAM intern Christian Schoening carefully transcribed an interview between the curators and Shambroom and the interview published in this book, among her many other duties. The Weisman registrar, Karen Duncan, and crew members Mark Kramer, Tim White, and John Sonderegger were invaluable in the registering and installation of the exhibition at WAM and in the preparation for its touring. The Weisman education department is to be commended for its thoughtful and relevant programming for the exhibition.

Several other professionals contributed to the production of this catalogue. We wish to thank our exceptionally gracious, flexible, and sharp editor, Laura Westlund. Her commitment to quality and clarity, her intelligence, and her editorial eye enhanced the publication. We thank her also for keeping us all on track during the book's production. We are indebted to the book's designers, Matthew Rezac and Andrew Blauvelt, for their elegant, thoughtful, and provocative design. Their exacting standards, hard work, and relentless commitment to quality made this catalogue the fine publication it is. We also thank Eric Recktenwald, who worked tirelessly and on short notice to assist the artist in the production of reproduction scans.

Finally, we thank the lenders of photographs to the exhibition — Paul Shambroom, the Walker Art Center, the Minnesota Historical Society, Anoka Technical College, and Artist Pension Trust — for their generosity and helpfulness.

POWER, POWER, EVERYWHERE… CURATORS' INTRODUCTION

DIANE MULLIN, HELENA RECKITT, AND CHRISTOPHER SCOATES

Photographer Paul Shambroom has grappled with subjects as wide-ranging as nuclear weapons, office interiors, and small-town municipal meetings. He has shown and discussed his work in venues just as diverse — from art museums and galleries to the Atomic Testing Museum in Las Vegas and the Apple store in SoHo, Manhattan. The common thread, the artist asserts, is *power* — his abiding and central subject from his earliest days as a commercial photographer in the 1980s to the present. Though his series have been individually exhibited, published, and discussed in the United States and Europe, to date no museum exhibition or catalogue has rigorously combined and critiqued several of his projects. Paul Shambroom: Picturing Power for the first time brings together selections from his five most important series: Factories (1986 – 88), Offices (1989 – 90), Nuclear Weapons (1992 – 2001), Meetings (1999 – 2003), and Security (begun 2004). Comprehensively, these series look penetratingly at how everyday citizens intersect with, and influence, the dominant institutions of their times.

Factories and Offices mark Shambroom's earliest attempts to grapple with powers seemingly beyond our control but integral to our lives. He visited manufacturing sites — from the most gritty and heavily industrial to gleaming high-tech plants of computer and biotech businesses — and corporate complexes to capture scenes of the spaces where most Americans spend the majority of their time. For his Nuclear Weapons series, he gained access to long-restricted nuclear sites and produced eerie images of slumbering bombs and immaculate, empty war rooms, highlighting the nuclear threat that still lingers after the cold war. For Meetings, he traveled to town council meetings in small communities as far-flung as Maurice, Louisiana, Yamhill, Oregon, and Lee, New Hampshire, where he photographed public officials in a formal portrait style, calling up both the seriousness and banality of these gatherings. Security turns again to the portrait, but now that of the heroic individual, along with tableaux-style images of training maneuvers that emphasize the dramatic quality of the actions themselves. Past and future, reality and fiction blur as each figure or scene creates a picture of threat and resistance in our post-9/11 age.

While varied in subject matter, Shambroom's series all record and demystify little-seen loci of power. His images are remarkable both for their stark portrayal of such places and as evidence of his access to the sites; negotiating this access in an open and democratic manner is a hallmark of his practice. Embodying curiosity, persistence, and empathy, his work illustrates and champions engaged citizenship and democracy — yet, despite this strong social and anthropological bent, his photographs are hardly straightforward records. With their rich colors and formal compositions, they tease out the latent drama, humor, and absurdity of their subjects, however frightening or mundane. Framing and subtly manipulating reality, they reveal the constructed nature of all documentary images, and of political representations in particular.

Shambroom's belief in the importance of individuals engaging with the power structures of the times situates his work firmly in the contemporary discourse on power — a rich cross-cultural and cross-disciplinary field. Paul Shambroom: Picturing Power participates in this critical discussion, arguing that, in our age of global policing and politics-as-spectacle, Shambroom's commitment to active citizenship and democracy is not only relevant but vital. He deeply desires that his work be a catalyst for inclusive and thoughtful dialogue that can help enable individuals to make conscious and informed decisions. This exhibition and catalogue seek to facilitate this process by presenting this body of work and also offering multiple voices and perspectives on it. Not meant as a beginning or an end point or a definitive statement, we hope this will further what Shambroom began twenty years ago when he took the first photographs for Factories. As with the democratic process itself, his photographs invite the viewer in and ask for a response. Institutional power may be pervasive, but instead of approaching government, industry, and the military as inaccessible monoliths — with not a drop to drink — Shambroom's photographs urge us to discover through open, democratic discourse the power that is available to us and within our capabilities to enact.

PROCESS AND PERSPECTIVE AN INTERVIEW WITH PAUL SHAMBROOM

STUART HORODNER

This interview was conducted in Minneapolis on February 10, 2007.

S.H.: Yesterday you and I were talking with students when a young woman asked whether you had been in the military, which led to the question "Have you ever shot guns?" What is your experience with guns?

P.S.: I don't have a lot of experience with big guns, mostly little guns. When I was at summer camp I liked to shoot guns, and I was actually a very good shot. It was one of the few things I was really good at in terms of competition and athletics.

This was in New Jersey?

Yes, a YMCA camp full of Jewish kids.

What did your parents do?

My father worked in advertising. He worked on Madison Avenue as an account executive for a couple of different advertising agencies, which engendered great disdain in me for the advertising business. I swore I would never have anything to do with any part of it — although eventually I did. I worked as a commercial photographer for many years and made my money doing that.

Advertising had a presence in our home. I remember when we watched TV and my father would quiz us after the commercials. He would say, "Okay, whose product was that? What was that a commercial for?" If we couldn't say, well, that was Adam Hats or whatever, then he would say, "That wasn't a good commercial, because you don't remember the name of the product." Some of his clients' commercials would come on TV and we would all get excited and say, "You worked on that!" But he was a "suit"; he was not a creative, as they say in that business.

Seems like you had very formative experiences with how images and ideas work. My dad worked for the American Photographic Corporation, right near Madison Square Garden. He was the production manager for the copy and restoration department in the days when people would go to department stores with their old picture of Uncle Leo with a big crack down his side; these photos were routed to APC. He brought home interesting photos, Mathew

Bradys, weird family pictures, things he just thought were interesting and wanted to share.

Did you grow up in the city?

I grew up in the Bronx.

Then you were a Yankees guy, right?

No, a Mets fan. The Yankees were too damn good — they weren't interesting. The Mets stunk. When they won the World Series in 1969 you had to believe in a God.

I was a Yankees fan when I grew up in Teaneck, New Jersey, where fans fell clearly along class lines. The kids who lived on the other side of the track where the golf course was, they were Mets fans. The Mets were more high class and the Yankees were more working class.

I have to show you something that has to do with my father and photography. I found out that he was photographed by Diane Arbus.

Are you kidding me?

When I was in college I was writing a paper about Arbus; she was and still is a big deal to me. I was researching this paper at MCAD [Minneapolis College of Art and Design], and I came across an article — I think it was in <u>ArtNews</u>. She died in what, '71, and then in 1973 this writer she worked with wrote a remembrance of her. Look at what he says. I was sitting in the library reading this.

(reading) "I have never had more fun being paid to work than I did with Deeyann — as everyone pronounced her name. Our trail led us to a host of talented people with fascinating names and titles. The ad agency chief was named Mogul; the account supervisor, Guttenplan; the account executive, Shambroom. The National Shoes official-in-charge was the 'low-heel buyer.' Deeyann, her eyes widening like camera apertures, watched several of our subjects wining me and dining us (Deeyann did not drink). She was, she said, a person to whom people with funny names happened."

This is by Alan Levy, the writer who worked with Arbus on that assignment, one of the first assigned magazine pieces she ever did, on the

Item #6. The vice-presidents have agreed upon a pitch, and now William Shambroom, the account executive, must run with the ball and see who salutes. He is responsible to Milton Guttenplan, the account supervisor. Confusion? Si! Duplication? No! Mr. Guttenplan <u>makes</u> policy. Mr. Shambroom <u>implements</u> policy.

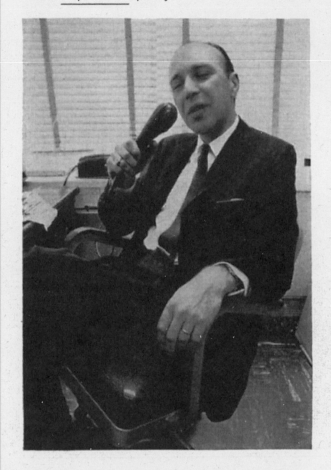

86 SHOW: SEPTEMBER 1962

William Shambroom photographed by Diane Arbus for an article in <u>Show</u> magazine, "56 Seconds + $56,000 + 150 People = ? or, The Sell behind the Shoe," September 1962.

making of a television spot. [Levy's tribute is "Working with Diane Arbus: 'A Many-Splendored Experience,'" ArtNews (Summer 1973).] So I am sitting in the library, a college junior researching this paper on Arbus. I gasped and practically fell off my chair. I called my father and said, "What the hell?" and he said, "Yeah, yeah, she took my picture."

So you came upon this by chance? He never told you?
No, I had no idea.

So research pays off!
Here is the picture. Yeah, there he is. Not long before he died, he showed me this magazine, and he said, "I don't understand what the big deal is about this Diane Arbus. I mean, look at me, my eyes are closed in this picture." I treasure this so much I can't even tell you.

He had one copy of the magazine, which he gave to me — Show, from September 1962, one of the picture magazines like Look or Life. The name of the article was "56 Seconds + $56,000 + 150 People = ? or, The Sell behind the Shoe."

If Arbus is someone to whom people with funny names happened, what are you?
As far as my work goes, there really is no direct lineage, but there may be some connections with Arbus . . . I do have my own collection of funny names, mostly from military and security people I've worked with. A communications specialist at one of the homeland security training places in Texas was Bud Force, and there was Luanne Fantasia (Army Public Affairs) and Lieutenant Flex Plexico (Navy Public Affairs). I was partially inspired by Arbus's collection of names — these business cards are all on my bulletin board at my studio.

When you grabbed your laptop yesterday to project an image to the class, it dawned on me how much of your work is made possible by the computer. Could you talk about its use as a research tool, as a processor for image making, and how it affects your practice?
I'm probably the perfect guy to ask about that because the computer as a useful tool was introduced in the middle of the twenty

to twenty-five years that I've been doing this work. It has affected both the research and the production of my work. As far as research, my Meetings project was initially done without any computer assistance (I'm talking about the process of finding where the meetings are and planning how to get to them). When I first started, I used printed directories that I would get from state and municipal organizations. The Minnesota League of Cities Directory showed, for example, which communities would meet the second Tuesday of the month, and I would go through and check off with a pencil, out of several hundred entries, this town, this town, and this town are all meeting tonight, and then I would put little colored tabs on a map so I could see, okay, there's a little cluster of meetings here. But it would take hours; every time I wanted to go out it would take hours to do this. And then I went to a computer, which was still an enormous amount of work. I always seem to pick projects that require some obsessive-compulsive gathering behavior. I started getting the directories in electronic form and entered them into a database (another painstaking process). Once they were in the database I was able to use mapping software. I could just punch in "Minnesota — Second Tuesday — Towns Less Than 2,000," and get a list and have it plotted on a map.

I remember you showed me that matrix of data in the studio a few years ago. It would get you closer and closer to knowing what's available and where it is.
In fact, I did this identical task both pre- and post-computer. It wasn't previously impossible, but I certainly wouldn't have been able to accumulate as much information, to have the depth, to know about as many meetings, without the computer. It was important to take a lot of photographs, and because of the computer I could attend and photograph more meetings.

Print production on canvas wouldn't be possible without digital inkjet output coming to a certain level of maturity at just the time when I desired it for aesthetic and conceptual reasons.

I'm interested in how you shape perceptions of place and power. In your Offices series

there is a kind of intimate everydayness and anywhereness. There are no people, but there are traces of them, spaces for them. In Nuclear Weapons, which seems almost abstract, one gets lost in the overall compositions of huge metal structures and dense hardware. They are like establishing shots in film, with as much context as you can pack into the picture. In Meetings the figures are not only prominent, they are practically religious, set into unique small-town architectures. And in the recent Security series, the figures are 75 percent of the picture.

The Security portraits are more influenced by and in a conversation with pre-mass media image making. You know, the conventions in art history of portrait making, particularly in eighteenth- and nineteenth-century Europe.

Celebratory portraiture?

Yeah, the celebratory portraiture exclusively made of the privileged.

The winners.

Yes, the winners — the leaders, military and civic and business leaders. Those are some of the visual vocabularies I'm dealing with that are not necessarily referring to modern mass media (as we think of it now). No artist working today, in any modern society, can be without influence from the mass quantities of images. It's almost a cliché to talk about it: we see so much.

My projects change stylistically, and I guess I don't feel married to a particular visual style or strategy. I'm somewhat of a chameleon in how I choose my strategy. But the common impulse is to make things that are visually compelling. To me it's not enough that there be a compelling concept . . . I'm not interested in work that is conceptually interesting but flat. I want people to be drawn in on a very visceral and visual level to look at what I'm doing. I employ a variety of strategies, one of which is scale.

And, really, I love photography. Part of the formal vocabulary of photography, particularly modernist photography, is very complex and beautiful. I like to make beautiful things. This is not an original idea, but to me the intersection of beauty and horror adds a tension that's important to me and to any of the images I make.

There has to be something to keep people in front of the picture while they take on unfamiliar or difficult content. Lushness can be a hook.

Yeah. One of the hooks with the work that I print on canvas is the dialogue between painting and photography. From across the room it looks like a photograph and you get closer and it starts to look like a painting and then you step back and it's a photograph again. So there's the "What is this?" question. But with the Security portraits, they look at first glance or second glance to be, what's the word, iconic. They are supposed to present people as being heroic. But then there's a series of questions that you start to engage with as a viewer: this person is here to protect me, but do I really feel safe — safer — knowing that this person is in this gear doing this job?

Their gestures are very awkward. Whatever esteem or confidence they might suggest, there's a kind of astronaut clunkiness to them, which I really love. There's something very out of sorts in how they occupy the spaces that they're in — a foreignness and vulnerability. A couple of the guys in your Security images seem to be in confident poses but they are also quizzically bent.

I studied the conventions of portrait painting seriously while preparing for this project. I was traveling in the U.K. and went to the National Portrait Gallery and the Tate, and here, too, I've been looking at a lot of those portraits. Part of the weirdness you're describing is that these guys are in full protective gear in these bucolic environments. That also occurs in almost all those paintings that I looked at in England and in the American versions, too, like Gilbert Stuart's well-known full-length portraits, in particular of George Washington. He looks stiff. The subjects are very mannered and posed. They don't look comfortable. I was familiar with some of the conventions of that posing from my days as a corporate commercial photographer. I shot many executive portraits, and those conventions carry through to today. I never thought of that consciously; I just knew how you're supposed to pose a corporate executive to make him look like a corporate executive. But they are the same mannerisms that were used

by Thomas Gainsborough and Joshua Reynolds and Velázquez.

How much control do you have over these people's poses?

Complete and total control. Stand here. Put that leg forward. Let's see how it looks if you put one hand on your hip. Here, hold this thing this way. I would actually move their fingers to refine how they were holding the gadgets . . . It was a little difficult, because as you commented many of them are wearing masks and full protective gear. Sometimes I had to speak with them by radio because they couldn't hear. They're breathing self-contained oxygen inside their suits.

Do you sense that they are aware of their image being constructed as you're shooting? What is their response to what you're doing?

Oh, absolutely. The process begins with getting permission to be in these sites in the first place, and then explaining what I want to do to the public affairs people I'm working with. They buy into it or don't. Almost always they did, and that was partially based on my showing them examples of what I'd already done. So they would find a model who was usually a trainer — someone who worked at this institution and knew the gear. Realism is essential to me; even though the photographs have a layer of artifice with lighting and how they are posed, I wanted to be careful that the way they were dressed and the way they were handling the gear were accurate.

Once I'm at these sites, once I've negotiated the access and I'm there, I can't really say if there's an awareness or misgiving on their part that these images might be used in a context that we're not comfortable with. I think the fact is that they can tell that I'm straight in how I deal with them. I'm not deceitful. I tell them what I'm doing and what it's for, and sometimes I mention how the photographs can be read in a variety of ways. Some people who write about them see them as a critique, see them in ways that the public affairs people might not be happy with. But, on the other side, they themselves are happy with the photographs. I take Polaroids as I work, and they can see that I'm serious about what I do and that I know what I'm doing and am skilled at image

making. They can see that I'm treating them with respect both on a personal level and for what they do, the jobs they do. I believe that, too; I don't think I'm being two-faced about it. I do have respect for these people, and that has nothing to do with whether I think the policies that they are carrying out are the best policies for our country and for the world. They believe that they are doing the right thing and they are. I'm happy that there are people training with this stuff and there are first responders who know how to deal with the chemical weapons environment and that sort of thing. I'm just not sure these activities address the core of the problems we face in the world.

How do you judge the success of the work?

The first way into this discussion might be my ideas about my role as an artist in society and the value I place on that and that society places on it. Teaching has been helpful for me to consider how I talk with students and model a life as an artist. I feel strongly that artists are valuable members of society. We're not inherently disenfranchised; that is a self-fulfilling prophecy, when artists piss and moan about not being given respect or economic opportunities. We have a very significant place in society, but we don't take advantage of it often because we feel ourselves powerless. To me, *empowerment* is a term that has been so overused that it virtually has no meaning. But I feel strongly that this is a completely valid role for me to be playing. I don't have my tail between my legs when I approach the power structures and the people here (in the photographs) and say, "Yeah, I'm an artist and I'm working on this and I want to come in and look at what you do here and show work and publish books." It's part of the dialogue, different from what the news media does and different from what the entertainment industry does, but related to both.

In preliterate societies, artists were the singers of songs. You would recite an ode to this or an ode to that, and it's delivered through your eyes but it is helping . . . This might seem grandiose, but it's a way to help the society at large process the events of the day. Process and question, sometimes celebrate, sometimes parody and critique.

Ideally, the viewer uses that opportunity that you, as singer of songs or presenter of information, have provided. If you've presented the material in a thoughtful or complex or mysterious enough way, then they will wrestle with the same issues or some of the issues that you're engaged with, or with issues that the culture is defined by.

That's exactly my hope for my whole life as an artist — that this is the result. The word *discussion* is important. I really don't set out to provide answers. It has to do with a lot of discussions going on about political art, if we could even know what that is. It's important to me to try not to be didactic, at least not on a crass level, hitting people over the head and saying, well, here's what I think, you should think this, too. Or look at this, isn't this terrible? Can't we all agree that this is terrible?

You said something that stuck with me: "The intention and the integrity of the photographer should count for more than anything else in whether we believe what we see in a picture."

You actually did dig through the press links on my web site. [The quotation is from "A Conversation with Paul Shambroom," by Joerg Colberg, in <u>Conscientious</u>, December 6, 2006, http://jmcolberg.com/weblog.]

How do you think that integrity and intention are established?

Based on what you've done — that's the only way. I was talking then about veracity, and I say that because there is no other way to judge now. Photographs are inherently deceptive; they have always had that capability. Ever since photography was invented it was immediately seized upon by charlatans and con artists. We were talking yesterday about the show at the Met on spirit photography [the exhibition <u>The Perfect Medium: Photography and the Occult</u> at the Metropolitan Museum of Art]. Within ten or twenty years after the birth of photography it was being used for conning.

It's presumed truth was co-opted.

Right. And that's always been its strength. As any good con artist knows, your mark has to believe you on a basic level, say "Oh yeah, this guy's telling the truth," before you can do your con. Photography has always had that. It's a little premature, but I'm mourning the death of it, because as people become more media literate they develop a distrust of images. You know, it's taught now, media literacy is taught in public schools, in junior high school and high school. People are learning to distrust images on an intellectual level, but I think on an emotional reactive level you still immediately trust a photograph. I'm sure we're losing that. It's like a vestigial tail, a tailbone that we don't need anymore. In another generation or two, I suspect people will not believe a photograph, and we'll lose one of the special qualities of photography.

I've been thinking about your work in the lineage of Lewis Hine, Jacob Riis, August Sander, artists you probably feel an affinity to.

It would be an honor to be in that company.

The work made by those men reached audiences and changed public consciousness.

It's good to bring up those people, particularly someone like Lewis Hine, because there was a lot of discussion in the 1970s in academia about documentary photography and this idea that you can change the world. It was basically pooh-poohed at that point by theorists. Now, of course, it's interesting to revisit these questions of the power of images in light of the Rodney King video and the Abu Ghraib digital snaps, although these were not made by professional "do-gooder" photographers.

There are also real class problems to consider. It was always the privileged class, including Lewis Hine and myself and everybody else, saying, "Well, isn't this terrible, look at these poor people." There are all kinds of questions of exploitation and career building based on the misfortunes of others. I'm aware of that; I've read all that stuff and I have absorbed and agree with a lot of it. It's helpful to me — it's given me a humility as a maker. Sometimes I feel I'm on a mission, that I'm doing something important. But it's good to have this other voice in my head saying, "No, you're not changing the world. You're not going to stop the proliferation of nuclear weapons. You're just a guy taking pictures." I have a dialogue in my head between both of those voices.

In some ways I've become very obsessive and driven: not only is what I'm doing really important but I'm the only guy who can do it. These are definitely delusions of grandeur but I do know how to do these things. With the Nuclear Weapons project I had that feeling after I'd been working on it for several years. Going down this path, I know how to do it. No one else knows how to do it. And I'm not going to let anything stop me because if I don't do it, it's not going to happen. I still believe that I came out of that project with something that no one else will ever be able to get because that door is closed now. Whether history will judge it to have value or import is hard for me to tell. It is necessary to my process to have those delusions of grandeur as long as when I come down I realize that's what they are and I still have to wash the dishes at home.

—

Stuart Horodner is curator at the Atlanta Contemporary Art Center. He was formerly director of the Atlanta College of Art Gallery, curator at the Portland Institute for Contemporary Art in Oregon, and director of the Bucknell University Art Gallery. He is a contributing editor for Bomb Magazine and the organizer of the Affair, an intimate art fair at the Jupiter Hotel in Portland.

CHIM CHIMINEY PAUL SHAMBROOM, THE DOCUMENTARY TRADITION, AND THE SUBJECT OF WORK

DIANE MULLIN

1 Jean-François Chevrier, "Documentary, Document, Testimony …" in Frits Gierstberg, Maartje van den Heuvel, Hans Scholten, and Martijn Verhoeven, eds., Documentary Now! Contemporary Strategies in Photography, Film, and the Visual Arts (Rotterdam: NAi Publishers, 2005).

2 Conversation between Paul Shambroom, Diane Mullin, Helena Reckitt, and Christopher Scoates, July 12, 2006.

3 For more on this subject, see David E. Shi, Facing Facts: Realism in American Thought and Culture, 1850 –1920 (London and New York: Oxford University Press, 1995).

Paul Shambroom's earliest cohesive photographic series, Factories (1986 – 88) and Offices (1989 – 90), focus on places of work. Catching glimpses of the spaces of industrial factories and corporate offices while working on commercial jobs, Shambroom began to ponder what interested him most about these common, almost clichéd, and generally uncontemplated environs. To delve into those more personal interests and responses to the spaces he had been portraying for corporate annual reports, he first used his connections to individuals in local businesses and honed his now signature letter-writing skills to arrange access for private shoots. Concentrating on the spaces, instances, and details never appropriate for official publications, his catalogue of American workplaces at the end of the 1980s tells a very different story from that told by the corporations themselves. From trivial details such as the mark left by a potted plant on a mundane carpet (Plate 14) to the aftermath of a corporate buyout (Plate 16), Shambroom started to develop in this early stage of his career both a visual lexicon of the American workplace at the end of the Reagan years and the unique approach that would become his contribution to the tradition of documentary photography. These early photographs not only reveal the simultaneously generic and chaotic nature of the spaces of work but also show how work space and work itself — even if begrudgingly — are knit tightly into American society. In one image from Offices, for instance, a "Happy 30th Birthday" balloon floats above cubicle walls, evidence of the somewhat uneasy but seemingly acceptable, even normative, blending of the professional and the personal in the United States (Plate 11).

When broadly considered, the subject (matter) of work emerges central in American documentary photography. The best-known American documentary images are Lewis Hine's child laborers and Dorothea Lange's migrant farmers, proving the importance of this topic. Work, in fact, is elemental to American life and a key component of the so-called American Dream, both an inherently good action and a means to the fabled "pursuit of happiness." Shambroom's Offices and Factories series suggest that the importance of "work" (or "labor," to use a distinctly non-American term) may mean more than what is explicitly pictured. Though never his overt subject again, the idea and reality of work is at play in all of his major series, particularly in Meetings, in which he presents not only everyday labor but also the work of democracy in practice and that of the documentary photographer himself. With his "inside the whale" approach, Shambroom creates complex projects in familiar environments, photographs that are in the American documentary tradition as well as in the discourse of American democracy — as ideal and as practice.

There is a resounding chorus of agreement among photographers, historians, and critics that the term and even idea of "documentary photography" is without a solid and consistent basis. For some this marks a lack that cripples the practice and its discourse. For others, the ever-shifting definition is evidence of the field's strength and fluidity. In a recent essay on the documentary tradition and its current possibilities, Jean-François Chevrier begins, "The notion of documentary photography covers a variety of practices almost as wide as the idea of photography itself."[1] Shambroom has weighed in on the notion of documentary and his relationship to the tradition and practice: "[documentary photographer] is a description that I've gone back and forth about feeling comfortable with. When I first started working as an artist I didn't really like the term. I thought it was limiting … But now that I am less of a documentary photographer, I'm more comfortable with it."[2] The problem of the lack of a definitive definition aside, or perhaps underlying, one can speak of a certain tradition of the documentary — both images and practice — at the center of American photography (and by extension American art) since the midnineteenth century. This mode in American photography is based in a particularly American interest in facts and realism. In the United States facts and objectivity in social thought and art became paramount in the late nineteenth and into the twentieth centuries, contributing to the success and persistence of the documentary tradition in this country.[3]

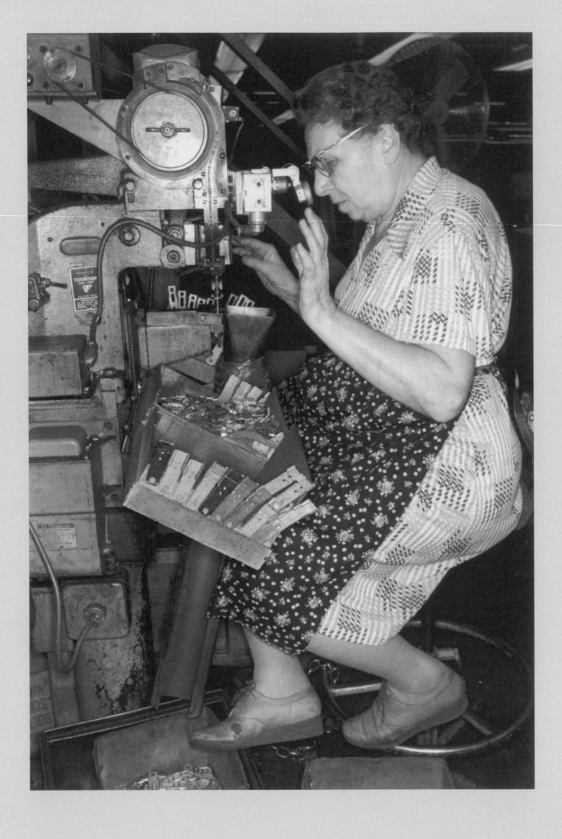

Lee Friedlander, <u>Canton, Ohio</u>, from <u>Factory Valleys</u> series, 1980.

4 Charles Baudelaire, "The Salon of 1859," in Baudelaire: Art in Paris, 1845 – 1862, translated and edited by Jonathan Mayne (London: Phaidon Press, 1965), 144 – 216. Originally published in Révue Française, Paris, 1859.

5 C. S. Peirce, Charles S. Peirce: The Essential Writings, edited by Edward C. Moore (New York: Harper and Row, 1972). The third category of visual sign identified by Peirce, along with icon and index, is the symbol, which was characterized by a representation of meaning, such as the rose as a symbol of love.

6 Paul Shambroom, application for Film in the Cities/McKnight Foundation Photography Fellowship, 1985.

7 Henri Cartier-Bresson, The Decisive Moment: Photographs by Henri Cartier-Bresson, translated by Margot Shore (New York: Simon and Schuster, 1952), n.p.

8 Shambroom, application for Film in the Cities/ McKnight Foundation Photography Fellowship, 1985.

9 See, for instance, the Metropolitan Museum of Art's categorization of Friedlander, Arbus, and Winogrand in "The New Documentary Tradition in Photography," http://www.metmuseum.org/toah/hd/ndoc/hd_ndoc.htm.

Much of the discussion about photography as document hinges on the photograph's relation, in semiotic terms, to reality and thereby its claim to the status of evidence. Chevrier maintains that photographs are not exclusively a product of the imagination but rather are based in actuality because by virtue of their production they, at the very least, *record* something; they have been understood essentially as documents, and as such they have historically been closely related to — sometimes believed to be — facts. Early in its history, photography was associated with the recording of actual fact or *evidence*. In 1859, the formidable art critic and poet Charles Baudelaire lamentingly reviewed the showing of "art" photography at that year's Paris Salon.[4] In this now famous article, he struck out against photography as an art form because for him art was defined by the imaginative, and photography was necessarily bound to the prosaic, or the real. In the early twentieth century, American mathematician and linguist Charles Sanders Peirce noted the peculiarity of photography in his newly devised system of visual signs: a photograph both, and in equal force, *resembled* and *recorded* what it imaged, thus making it iconic as well as indexical.[5] This aspect of photography has been exploited and celebrated by generations of documentary photographers, especially those who sought to use their photographs to *persuade*, politically or socially.

From the start of this project, Shambroom did not consider his Factories photographs as belonging to the documentary tradition. In a fellowship application to support the series (a grant he was awarded), he states: "My pictures are observations in the tradition of street photography."[6] Street photography is a style and ethos based on the idea of the photographer as a disinterested wanderer who, moving spontaneously and working through feeling, attempts to become one with the subject or scene he or she photographs. A major early practitioner was Henri Cartier-Bresson, whose photo book The Decisive Moment is one of the most important examples of the idea and look of street photography. At the beginning of this book Cartier-Bresson tells the viewer: "These photographs taken at random by a wandering camera do not in any way attempt to give a general picture of

any of the countries in which that camera has been at large."[7] In his fellowship application, Shambroom qualifies his self-identification with street photography by claiming that instead of striving to be a detached observer he will in the proposed series work intuitively with a goal to be "responsive to forces and balances in the visual environment." And (perhaps even more significant, given what we know of his mature practice) he continues: "Ideally, the viewer will be able to respond in an equally intuitive manner to the visual interest of the recorded situation."[8]

Shambroom was most influenced by the more recent street photography of Lee Friedlander, Diane Arbus, and Garry Winogrand, who were being sealed in the canon of great photographers at the time he began seriously practicing photography. Their cooler, at times more ironic and even self-deprecating, version of street photography was a harbinger of a postmodern attitude toward the monumental claims of photographers like Cartier-Bresson. It is not surprising that a young photographer would place himself in the context of his more immediate predecessors, especially those who were enjoying substantial critical and popular attention. This trio, while often affiliated with street photography, simultaneously came to be known as key artists in the "new documentary" tradition.[9]

Elaborating on his original interests and intentions in the fellowship's interim and final reports, Shambroom explains that factories as spaces of chaos, change, and "unintended visual poetry and drama" had initially excited the street photographer in him. Also of early interest to him was what he describes as the exoticism of the factory interiors. Most people, he comments, know factories only by their stark exterior walls. By providing glimpses within, the pictures, he asserts, have a "voyeuristic appeal" akin to travel photography. In this first articulation of what would become the Factories series, we can see the origins of Shambroom's now firmly established abiding concerns and commitments: the portrayal of evident but little seen environs, the curious nature of our everyday visual/visible surroundings, an emphasis on order in seemingly unruly subjects (from factories to democracy),

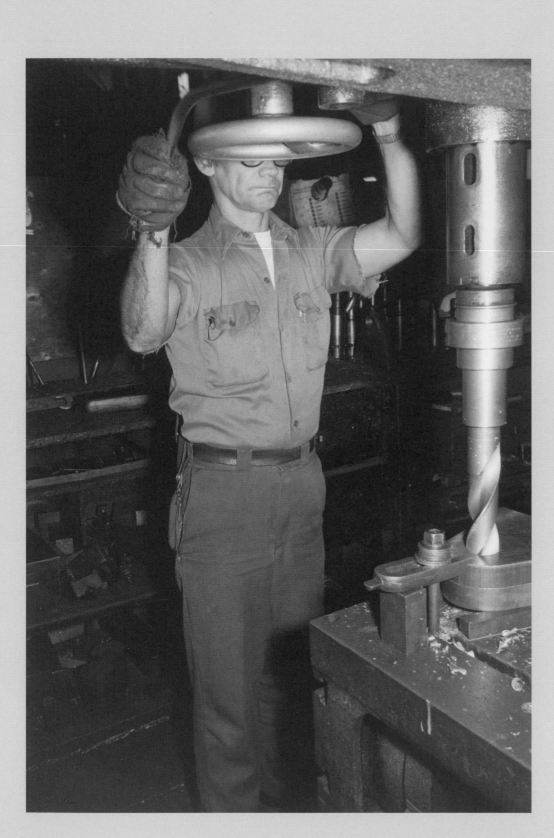

Lee Friedlander, Cleveland, Ohio, from Factory Valleys series, 1980.

10 Paul Shambroom, interim and final reports, Film in the Cities/McKnight Foundation Photography Fellowship, 1986.

11 Ibid.

12 Shambroom, final report, Film in the Cities/ McKnight Foundation Photography Fellowship, 1986.

13 Paul Shambroom, Jerome Foundation Visual Arts Fellowship application, 1987.

14 American Time Use Survey Summary, U.S. Department of Labor, Bureau of Labor Statistics, 2006 results, http://www.bls.gov/news. release/atus.nr0.htm. News, Employment Situation Summary, Bureau of Labor Statistics, September 7, 2007, http://www.bls. gov/news.release/empsit. nr0.htm.

and his relationship to and the role of the viewer in his practice and photographs.

In the grant's interim and final reports, Shambroom states clearly that the project veered from his original interests and plans. This shift concerned the nature of the subject and the formal and technical aspects of the work. One key change hinged on a new focus on the environs instead of the people in them:

> The work I've done has taken a different direction from what I originally expected. After consciously trying to make "street photos" in the factories, I have realized that the places themselves are more interesting to me than the people working in them.[10]

Though figures appear in many of the images, they are not central and are certainly not mined for the "decisive moment" the photographer had originally hoped to reveal. Instead, the actual spaces of the factory interiors were more interesting to him, and a new approach — away from the street photograph — was emerging. At this early point, Shambroom indicates a number of other traditions and strategies to contextualize his work, naming landscape and at least referring to documentary. In his report of activities during this grant period he lists that he spent time viewing the work of other artists who dealt with subjects similar to his own, including Lewis Hine, a prominent photographer in the documentary tradition. In a discussion of his formal process (particularly lighting) Shambroom uses the term "documentary" but significantly encloses it in quotation marks:

> I've tried to minimize the distorted color that often results from artificial light sources, so that the prints have an accurate "documentary" feel to them. Photographs have an inherent "believability" that adds weight to their content. In this work I'm trying to make the formal aspects compelling enough to compete and resonate with the content.[11]

This passage reveals again a certain distancing on Shambroom's part from the traditional claims of socially minded documentary photographers and their celebrators. Presenting the terms *documentary* and *believability* in quotation marks, he signals his astuteness to the problematic nature of the commonly held belief in the truth-value of such photographs. He thus positions himself as educated and practicing in a post-1970s era — a period that produced artwork and critical writing that interrogated modernism's grand narrative and claims, much of which revolved around new critical thinking on photography by Susan Sontag, Abigail Solomon-Godeau, and Hal Foster. Shambroom begins to stake his own territory as a photographer and is careful to set his tone. He concludes his final fellowship report by stating that he had attempted to "respond to the hidden order within the chaos," resulting in photographs "much more spatially ambiguous, layered, and complex than my earlier work."[12]

Though Shambroom's assessment of changes that had taken place during his 1985 – 86 fellowship year was not fully resolved and still predominantly formal in sensibility in 1986, his application for another grant in 1987 begins by announcing the *subject* of his project: "I will use the ... fellowship period to produce photographs exploring the changing visual environment of the workplace."[13] His subject, now more than just a record of visual interest, is to be understood as an exploration of an unfolding event — the changing visual environment of the workplace (presumably in the United States). Completely distinct from Cartier-Bresson's assertion that his photographs make no general statement, Shambroom defines his task as just that, the production of visual evidence that will cohere to show us something, a strategic base that will mark his subsequent work. In this application proposal he mentions Lewis Hine again, calling up his relationship to this documentary photographer through what he sees as their shared subject of "industry." He also mentions the precisionist painters Charles Sheeler and Charles Demuth, as he did in the 1985 – 86 fellowship documents, demonstrating the centrality of subject matter over even media for the artist.

According to recent labor statistics, 65.8 percent of the U.S. population is part of the labor force. The average American worker works 8.2 hours per day and earns two weeks each year of paid vacation time.[14] Reports state

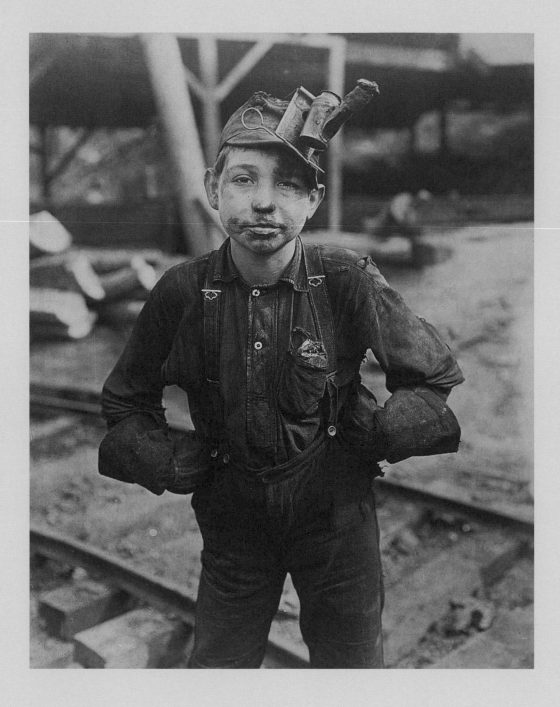

Lewis Hine, <u>Young Boy Coal Miner</u>, 1909–13.

15 U.S. Census Bureau news press release, March 30, 2005, http://www.census.gov/acs.

16 For views on this oft-stated comparison, see Tony Judt, "Europe vs. America," The New York Review of Books 52:2, February 10, 2005; and "World: Americans work longest hours," BBC News, September 6, 1999, http://news.bbc.co.uk/2/hi/439595.stm.

17 Robin M. Williams, American Society: A Sociological Interpretation (New York: Alfred A. Knopf, 1951; second edition, 1961; third edition, 1970).

18 Daniel T. Rodgers, The Work Ethic in Industrial America, 1850–1920 (Chicago: University of Chicago Press, 1979), 1.

19 Roger B. Hill, "History of Work Ethic," http://www.coe.uga.edu~rhill/workethic/hist.htm, 1999; last updated June 2005.

20 S. M. Lipset, "The Work Ethic — Then and Now," Public Interest (Winter 1990): 61–69.

21 Max Weber, The Protestant Ethic and the Spirit of Capitalism, translated by T. Parsons (New York: Charles Scribner's Sons, 1930; reprint, 1958 [1904]).

22 D. Yankelovich, New Rules: Searching for Self-fulfillment in a World Turned Upside Down (New York: Random House, 1981), 247.

23 Peter B. Hales, Silver Cities: The Photography of American Urbanization, 1839–1915 (Philadelphia: Temple University Press, 1984).

that the average American worker spends one hundred hours each year commuting to and from work — more than the time spent annually on vacation.[15] Compared to Europeans, Americans overall spend more time at work and less time at leisure or on vacation.[16] In his seminal analysis American Society: A Sociological Interpretation, Robin M. Williams determined a set of fifteen values that are central to the American way of life; work, along with individuality and freedom, appears on that list.[17] Daniel T. Rodgers's study of the work ethic in industrial America highlights the oppositional nature of Henry David Thoreau's critique of work and celebration of leisure, explaining that "to doubt the moral preeminence of work was the act of a conscious heretic."[18] Rodgers points out that Thoreau's countercultural valuing of leisure over work was at heart nostalgic; his emphasis on ease was based on a preindustrial idea of the role and value of work in Western society.

In his brief history of the work ethic, Roger B. Hill describes the evolution of attitudes toward work in Western culture from ancient Greece to modern times.[19] Citing S. M. Lipset, he states that work had not been understood as having value in itself until fairly recently.[20] For most of human history, work was considered difficult and even degrading — the domain of slaves. The wealthy and cultured spent their energies in the higher pursuits of thinking (philosophy) and cultivating society. Not until after the Protestant Reformation did physical labor become socially acceptable for the middle and upper classes. Sociologist Max Weber theorized this "Protestant ethic" in 1904 in his now classic text The Protestant Ethic and the Spirit of Capitalism.[21] This "ethic," which gave "moral sanction to profit making through hard work, organization, and rational calculation," became the dominant modus operandi of postindustrialized European and American culture and defined the modern era.[22] Though scholars from many disciplines, including history, economics, and sociology, have theorized various reasons for and results of this significant cultural shift in attitude about work, they tend to agree on the reality and monumental importance of the shift.

Photography, particularly that we know as "documentary photography," has played a key role in the discourse of this transition in industrial and postindustrial society, especially in the United States, where the work ethic is tied closely to democracy and independence. The Progressive-era documentary photographers were at pains to show the fissures in the idea of work as yoked to the free and self-contained individual who, by working, builds moral character. The first fifteen years of the twentieth century marks the firm establishment of the reform photography movement, which started at the end of the nineteenth century with Danish-born photographer Jacob Riis. Reform photography aimed to persuade and promote a social or political agenda, such as, in the case of Riis, improvement of living conditions for the working urban poor. Though there were instances of reform photography before Riis, his work between 1885 and 1895 was a model for the development of a coherent and forceful tradition — the one we now know.[23]

Lewis Hine is perhaps the most significant practitioner of Progressive-era reform photography. He was driven to expose the inequities that marked the division between the rich and the poor, the powerful and the vulnerable, the adult and the child in this seemingly open and democratic system. Though the "Protestant ethic" did legitimize work even for the wealthy, the reality was that the wealthy still aspired to and achieved a "higher" level of work — one not based in the spaces of heavy industry. Hine's Young Boy Coal Miner (1909–13) is a portrait of a child worker whose everyday labor consisted of long hours, physical toil, and harsh environments. The boy, meant to appear both suffering and full of potential, is presented straight on, as if confronting the viewer, who is meant to be shocked by his situation. Hine was very strategic about how he presented his subjects in order to be the most persuasive. Battling a basic and pervasive American prejudice against the new wave of immigrants from southern and eastern Europe and Ireland, Hine and his fellow reformers had to be careful not to reinforce the stereotype that these workers were by nature less hard-working than the immigrants from Northern Europe. Hine's

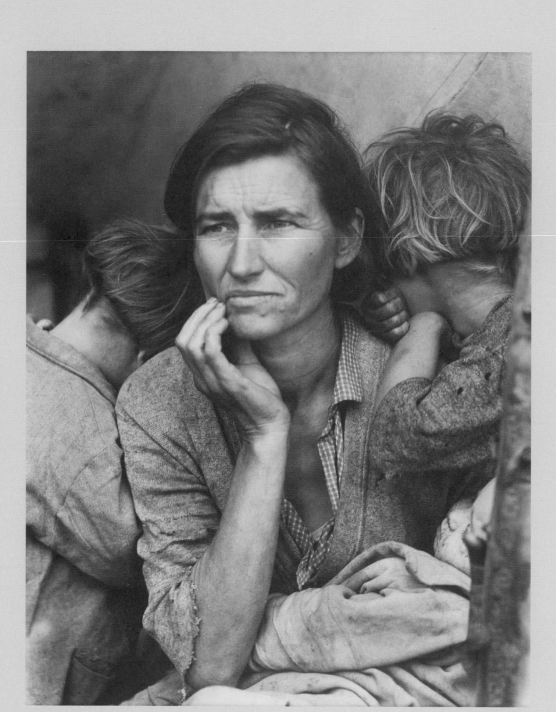

24 James Guimond, <u>American Photography and the American Dream</u> (Chapel Hill and London: University of North Carolina Press, 1991), 67 – 69.

25 Carl Fleischhauser and Beverly Brannan, eds., <u>Documenting America, 1935 – 43</u> (Berkeley: University of California Press, 1988).

26 Lee Friedlander, <u>Lee Friedlander: At Work</u> (New York: D.A.P./ Distributed Arts Publishers, Inc., 2002).

appeal to the public relied on this delicate balance of picturing the pitiable and honorable aspects of these workers.[24]

The next great period of American documentary photography, during the Depression of the 1930s, produced a plethora of images about work. Dorothea Lange was among the most tireless and important artists employed by Roy Stryker's Information Division of the Farm Security Administration (FSA). Her iconic images were powerful statements that fulfilled the government mandate to depict the American worker as strong, honorable, and connected to the land, intended to reinforce the FSA belief that poverty could be remedied by changing land practices.[25] Lange's <u>Migrant Mother</u> (1936) exemplifies her manipulation of artistic strategies and subjects to create a strong, persuasive, and palatable image of the American worker and, by extension, America itself. The portrait of the exhausted but clearly strong-willed and stoic mother (evident in the emphasis on the eyes and clenched jaw) suggested strength and goodness. By calling up the classic reference to the Madonna and child, Lange universalizes the plight of the American worker while portraying her, in keeping with American values about work, as naturally good and innocent.

Between 1979 and 1995 Lee Friedlander, Shambroom's relative contemporary, produced several photographic series focused on work in the United States. In 2002, he published a book, <u>Lee Friedlander: At Work</u>, that grouped these images together for the first time.[26] Friedlander's series had a variety of origins, including private projects, commissions by museums and individuals (one by a CEO as gifts for employees), and straightforward commercial work for businesses (annual reports and public relations assignments). Shambroom, an admirer of Friedlander's photography, asserts that their projects are distinct, especially because the <u>At Work</u> images are predominantly single-figure portraits of people actually doing their jobs. Yet affinities in the sensibilities of the two photographers can be seen in these portraits, notably a certain sense of the absurdity of the mundane that Friedlander and Shambroom share. In a photograph from the <u>Factory Valleys (Ohio/Pennsylvania)</u> series (1979 – 80),

Friedlander uses an angle that makes a man appear at one with his machine, but not in the heroic manner common to the depiction of industrialization in the 1920s, 1930s, and 1940s. Rather, Friedlander presents him in a comic, even disparaging, manner: a machine part obscures the worker's eyes and at the same time looks like an ill-fitted hat or even a strange lopsided halo. In another photograph from this series, a woman is at once in an embrace with and trapped by the machinery she operates. In a later series, Friedlander explores the new landscapes of telemarketing and the computer industries with the same dry, even sardonic emphasis on the slightly ridiculous nature of the humans who work the machines. Similar to Hine, Friedlander constructs his images to push his intended message, but unlike Hine he does not seek to effect change but instead without empathy critiques humanity and its conceits.

Shambroom also, on occasion, delights in glimpses of the absurd. In <u>Minuteman II Missile in Transporter Erector Vehicle, Ellsworth Air Force Base, South Dakota</u> (1992; Plate 26), human legs protrude from a nuclear warhead as if it had sprouted them. In <u>Texas Instruments, Dallas, Texas (semiconductors, missiles)</u> (1988) the abrupt juxtaposition of a pair of disembodied robotic arms with the nearby fully human worker is startling, a scene eliciting both comedy and relief. This sense of humor as the humane in the workplace — as opposed to Friedlander's more ironic tone — is evident across <u>Factories</u> and <u>Offices</u>.

Shambroom engages work as subject in other series as well. The <u>Nuclear Weapons</u> pictures present places of work and at times people or traces of people at their jobs. Submarine control rooms (Plate 20) and official conference rooms such as that of the Joint Chiefs of Staff (Plate 23) draw out the relationship of these visual environments to the pictures of factories and offices in the earlier series. <u>Security</u> features places and equipment to train potential workers in new national security-related careers; portraits of the trainees and scenes of training maneuvers both highlight the tools and techniques of a burgeoning industry. But Shambroom's most compelling representation of work knit into American life is in <u>Meetings</u>:

Paul Shambroom, <u>Texas Instruments, Dallas, Texas (semiconductors, missiles)</u>, 1988.

Index-card records of phone calls requesting factory visits compiled and maintained by Paul Shambroom during the development and creation of <u>Factories</u>, 1986.

27 Robert Coles, Doing
 Documentary Work (New
 York and Oxford: Oxford
 University Press, 1997).

28 Conversation between
 Shambroom, Mullin,
 Reckitt, and Scoates,
 July 12, 2006.

29 Ibid.

30 See "Lewis Hine and
 American Industrialism,"
 chapter 3 in Guimond,
 American Photography
 and the American Dream.

for this series he traveled widely to photograph councilmen and councilwomen in the setting of formal municipal meetings. Although they may not initially seem images of American work, these portraits show people doing the work of American democracy. As representatives of their constituents, the subjects are engaged in making decisions — both small and large — that affect the lives of the people in their districts.

A study of Shambroom's interest in work would be incomplete — even misleading — without considering his own work, which goes well beyond photo shoots and darkroom and, more recently, scanning and printing. From the start of his career, he recognized the unique nature of his photographic practice. In the final report for the 1985 – 86 grant discussed earlier, he notes another aspect of the project that surprised him, in addition to his move away from street photography and the newly focused subject of the workplace:

> I have photographed in over a dozen different factories in Minnesota and Wisconsin. . . . Arranging these visits has been a surprisingly time-consuming process, involving letters and phone calls to each company.

This "surprise," which began with the first index-card records of phone calls about factory visit requests, would become the bedrock of his career for the following two decades. From 1986 on, Shambroom would hone these communication and contact skills into a full working strategy that must be considered in the history of documentary, in particular that of documentary work.

Robert Coles, preeminent psychiatrist and one of the founders of the Center for Documentary Studies at Duke University, reviews documentary photography in his incisive analysis Doing Documentary Work.[27] Discussing "location," Coles argues that the positions of both the documentarist (writer, photographer, filmmaker) and the audience are significant to the meanings that can be derived from the work. Shambroom is keenly aware of this problem — in fact, it determines his every move. On developing an "insider" status when working on Nuclear Weapons, he recently stated: "The more familiar I became with the terminology and the technology and the culture the more I felt like an insider. I questioned myself constantly on this."[28] Recalling the famous Stockholm syndrome, Shambroom's comments reveal a concerted and self-conscious effort to acknowledge his position, recognize other positions, and maintain what objectivity he could. Reflecting on his earliest decisions about the topics he would investigate, he also calls up ideas about position. He likens his work to that of a travel photographer but insists on focusing closer to home: "My subject matter . . . was partly a reaction to the idea that photographers were supposed to go elsewhere in the world and report on what they saw and bring it back . . . I just thought, you know, there's so much interesting stuff right here . . . so many interesting things about America that don't really get looked at."[29] He expands beyond his own initial visual or aesthetic interest to that of the viewer by focusing on the hidden and the close qualities of his subjects, thereby asking us to look more astutely and establishing our own sense of awareness of our visual and social surroundings.

Instructive here is another comparison with Lewis Hine. Hine's practice is as notable as the resulting images in that it defines one end of the spectrum of American documentary working strategies. He thought of himself as a spy and, on a mission to expose deplorable conditions, was known to secret his way into factories and other workplaces. He is reported to have misrepresented himself as an employee of machinery companies, asking to pose small workers by machines for a sense of scale. On occasions when he was turned away or run out, he would return before the very early work hours to try to talk to and photograph workers on their way into the factories. He published his pictures along with words about and uttered by the workers, and he used his photographs in conjunction with lectures and other public forums for change. His work — the entire enterprise — did contribute to progressive reform for immigrants and child laborers and endures as both historical document and art.[30]

Like Hine, Shambroom has utilized the book format, publishing monographs on Nuclear

31 Paul Shambroom, Face to Face with the Bomb: Nuclear Reality after the Cold War (Baltimore: The Johns Hopkins University Press, 2003); Paul Shambroom, Meetings (London: Chris Boot, Ltd., 2004).

32 Conversation between Shambroom, Mullin, Reckitt, and Scoates, July 12, 2006.

33 Ibid.

Weapons and Meetings.[31] He compares both publications to resource or reference books, especially Face to Face with the Bomb, which includes a section, "Notes on the Photographs," with specific information about the weapons and other related details, such as location, military terminology, and codes. The more general "Selected Readings and Resources" covers such topics as weaponry, photography, and relevant histories. Shambroom describes his motivation for these publishing strategies:

> I did develop a kind of … not a disdain … but I find myself having very little patience for anti-nuclear activists who are uninformed. People who would throw around incorrect information — it doesn't help the cause, not in my eyes and certainly not in policy makers' eyes. And that also helped motivate me to continue with this project as a kind of education mission. This stuff is complicated, but it's not too complicated. As citizens, we are responsible every time we vote … we're in essence helping to formulate nuclear policy for the United States, and I think it is vitally important that people have some basic understanding.[32]

Shambroom sees himself as a provider of information. Once offered, the information belongs to those who engage with the materials, images, and text. In his book Meetings, the photographs are accompanied by the minutes of each meeting. In the first showing of Meetings at Franklin Art Works, a nonprofit art space in Minneapolis, Shambroom hung facsimiles of the minutes and displayed on a personal desktop computer in the gallery his active database locating fifteen thousand municipal meetings throughout the United States. Essential to these display strategies is the sense of the viewer's place and the concept of being a service to the audience. Rather than staking a position or advancing an agenda, Shambroom thinks of his work as a dissemination of information — multimedia source books meant to contribute to each individual's thought and decision-making processes.

Unlike Hine, Shambroom works in the open, choosing to navigate into the spaces he pictures through the mechanics of American democracy. This technique was developed first in Offices and Factories and then in his pictures of nuclear weapons sites, municipal meetings, and training centers for new security careers that have emerged after 9/11. Hine worked in private spaces (a problem for Shambroom more often than not) and before the path-clearing decisions to open access to information, what are popularly known as Sunshine Laws. These state and federal laws, created in the mid-1970s, required that the public have access to regulatory authorities' meetings, decisions, and records; the legislation, post-Watergate, was an effort to increase public disclosure of governmental agencies. An avid reader of newspapers and other media outlets, as well as texts on politics and society, Shambroom researched these laws and learned just what was available to him, the "average citizen."

Also in clear distinction to Lewis Hine, Shambroom claims not to be out to persuade viewers: "I am not a political artist in the sense of trying to promote an agenda and right wrongs."[33] Instead, he presents his pictures and his open process as opportunities for viewers to think rationally about the issues that shape their lives. His considerable powers of persuasion are directed not to the viewer but to his own act of gaining and then providing access to what is ours to know as average citizens. In opening these unlocked but often tightly shut gates, Paul Shambroom gives us a view not only of monumental issues but of what is possible in a democracy if its citizens wish it to be.

——

Diane Mullin is associate curator at the Weisman Art Museum at the University of Minnesota. In Minneapolis she has curated exhibitions for No-Name Gallery at the Soap Factory and at Soo Visual Arts Center, a nonprofit contemporary exhibition space. She was assistant professor of art history and critical studies at the Minneapolis College of Art and Design, and has published in ArtReview, Art Papers, and New Art Examiner, as well as contributing essays to several exhibition catalogues.

GOING UNDERGROUND THE NUCLEAR WEAPONS SERIES BY PAUL SHAMBROOM

CHRISTOPHER SCOATES

> The Cold War may be over, but this does not mean nuclear weapons have disappeared. Far from it: There are almost 36,000 nuclear weapons in the world, thousands on hair-trigger alert, with more than a third of them ready to launch at a moment's notice, 24 hours a day, seven days a week.
> — Greenpeace

Since the United States dropped the first nuclear bombs over Hiroshima and Nagasaki in 1945, artists in all media, including visual arts, film, music, and fiction, have been addressing the theme of nuclear threat. László Moholy-Nagy's paintings Nuclear II and Leuk 5 from 1946 mark the beginning of a long history of visual artists preoccupied with these ideas. Important works about these issues have been created by many notable fine artists: Andy Warhol's silkscreen Atomic Bombs (1964), Roy Lichtenstein's Atom Burst (1966), James Rosenquist's painting F-111 (1964 – 65), Isamu Noguchi's Model of Bell Tower for Hiroshima (1950), Ben Shahn's H-Bomb Poster (1960), Robert Arneson's ceramic sculpture Nuclear War Head #6 (1983), Gregory Green's Nuclear Device (1996).

Nuclear war and weaponry have long been staple elements in hundreds of feature films, too. Classics include Stanley Kubrick's black comedy Dr. Strangelove or: How I Learned to Stop Worrying and Love the Bomb, in which an insane general starts a process to nuclear holocaust that a war room of politicians and generals frantically tries to stop; Alain Resnais's acclaimed film adaptation of Marguerite Duras's novel Hiroshima mon amour, which tells the story of a young French woman who has spent the night with a Japanese man in Hiroshima, where she went for the shooting of a film about peace; John McTiernan's The Hunt for Red October, portraying a Russian submarine captain who violates orders and heads for the United States in one of the latest Russian submarines; and Tony Scotts's Crimson Tide, an underwater drama on a U.S. nuclear missile sub, where a young first officer stages a mutiny to prevent his trigger-happy captain from launching missiles before confirming orders to do so. These films have framed and critiqued significant concerns for situations that might start a nuclear war today.

Science fiction novels have also addressed the fears of nuclear war. In H. G. Wells's The World Set Free (1914) an unspecified invention accelerates the radioactive decay that produces highly explosive bombs. Robert A. Heinlein's story "Solution Unsatisfactory" (1940) posits radioactive dust as a weapon that the United States develops in a crash program to end World War II. Nuclear weapons play a prominent role in Brian Herbert and Kevin J. Anderson's Legends of Dune prequel, in which humanity uses galactic-wide planetary atomic bombs against the Thinking Machines. Nuclear weapons have even been featured in children's books, such as The Butter Battle Book by Dr. Seuss, which deals with deterrence and the arms race.

In popular music, the list of songs with nuclear war, whether actual or contemplated, as the primary subject is almost endless. From the 1945 recording "Atomic Cocktail" by the Slim Gaillard Quartette to Doris Day's "Tic, Tic, Tic" in 1949 to Prescott Reed's "Russia, Russia (Lay That Missile Down)" in 1958 to "Enola Gay" by Orchestral Maneuvers in the Dark and U2's "Bullet the Blue Sky" in the 1980s, songs in all genres have covered nuclear war. Recently, the San Francisco Opera staged the world premiere of Doctor Atomic, an opera by John Adams and Peter Sellars. The impressive creative productivity of artists, filmmakers, novelists, and musicians who focus on nuclear-related themes indicates the breadth, depth, and scope of work that has been ongoing for more than six decades in all artistic disciplines.

In post–cold war America, artists continue to explore art's complex relationship to such charged topics. Nuclear war and nuclear weapons have been the subject for many photographers, including Richard Misrach, Patrick Nagatani, and Michael Light, as well as a loose organization of twenty-four photographers called the Atomic Photographers Guild, founded by Robert Del Tredici and including Peter Goin, Mark Ruwedel, and Carole Gallagher. These artists all have different agendas but make culturally visible various aspects of the nuclear age. Minneapolis photographer Paul Shambroom occupies a singular position among

1 See Martha Rosler, 3 Works (Halifax: The Press of the Nova Scotia College of Art and Design, 1981), 60.

2 See Grant Kester, "Toward a New Social Documentary," Afterimage 14, no. 8 (March 1987): 10 – 14. Kester emphasizes how social documentary offered a powerful position for dislodging modernist art photography and artist as genius.

these contemporary photographers because of his rigorous documentation of the unseen spaces of America's nuclear forces located at military bases across the country.

During the past twenty years, Shambroom has explored the complex relationship between the social and political through series of innovative photographic projects. He began working as an artist in the mideighties, when modernist art photography was undergoing a critical reevaluation. Several artists during this period, notably Martha Rosler, Allan Sekula, and Fred Lonidier, were forming a new critical photographic model that put political engagement front and center by connecting its practice with the tradition of social documentary, exemplified by progressive reformers such as Lewis Hine and the Depression-era photography of the Photo League and the Farm Security Administration. Their goal was to make art that openly embraced the political and pedagogical function of the image, rather than suppressing or concealing it, which so much modernist art photography attempted to do. By reconciling art with everyday experience and thereby harnessing the capacity of art to stimulate dialogue, these photographers endeavored to extend art's relevance far beyond a traditional and privileged audience. Their work illuminated a broad range of discourses, including art history, sociology, women's studies, architecture, urban planning, film and media theory, and contemporary cultural studies. As artists, activists, and writers, they contributed to ongoing discussions of social and political issues that shape all of our lives.

The adoption of the social documentary tradition by Paul Shambroom and others was far from uncritical. Poststructural theory, based on the writings of Jacques Derrida, Michel Foucault, Roland Barthes, and Julia Kristeva, had found its way into the art world by the mideighties, and two components of this tradition in particular influenced many artists of the time. First was the assertion that the meaning the author intended is secondary to the meaning the reader observes. Poststructuralism rejects the idea of a literary text having singular intention, a singular meaning, or one singular existence. A poststructuralist critic must be able to utilize a variety of perspectives to create a multifaceted, maybe even a conflicting, interpretation of a text.

It is important to investigate how the meanings of a text move and shift in relation to certain variables, usually involving the identity of the reader. When viewing social documentary through such a lens, a complex set of discursive practices like audience, creative and technical decisions by the artist, accompanying text or captions, and distribution factors plays into the meaning of the work. Social documentary challenged the solipsism and political non-involvement of art photography and carried with it a specific and objective prejudice. An image that demonstrates such a reading is Rosler's The Bowery in Two Inadequate Descriptive Systems (1974 – 75): it confronted the art photography tradition by pointing out how words and images that described urban poverty are always/already ideologically inscribed.[1]

The second lesson of poststructuralism was that the process of meaning was itself subject to political manipulation and dispute. The political tradition of social documentary and the critique of representation provided by critical theory offered a powerful opposition to modernist art photography. Artists recognized that their role was not necessarily pure genius or expressive spirit but rather a political conscience and creativity. Compositional techniques and formal and framing qualities of the work were not used to set hurdles or complicate meaning but to help elucidate the meaning inherent in the work. The representational language of the photograph, the framing, the image sequence, the visually dramatic scene or situation, or the use of text does not play up or focus on the creator but places significance on the complex representation of the social reality.[2]

In Shambroom's work, the "challenge of meaning" and art's complex relationship to visual experience are played out over several bodies of work. How does the image produce meaning? Is it a conduit to some higher truth or merely a veil drawn over reality? The rhetoric of visibility and invisibility, of revelation and disclosure, has remained central to Shambroom's practice over the years. Earlier series such as Factories (1986 – 88) and Offices (1989 – 90)

stewed
boiled
potted
corned
pickled
preserved
canned
fried to the hat

Martha Rosler, from The Bowery in Two Inadequate Descriptive Systems, 1974–75.

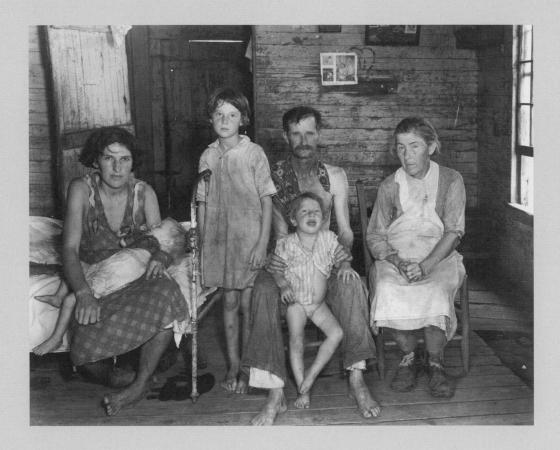

Walker Evans, Bud Fields and His Family at Their Home in Alabama, 1935, 1936.

3 Conversation between
 Paul Shambroom, Diane
 Mullin, Helena Reckitt,
 and Christopher Scoates,
 July 12, 2006.

depict a ground-level view of a conference-room table [General Mills, Inc. (#4), Golden Valley, Minnesota, 1989; Plate 13] or the elaborate scaffolding beneath a space shuttle under construction [Rockwell International, Palmdale, California (space shuttle orbiter Endeavor), 1988; Plate 5]. These pictures resonate with the tension between their strange formal aesthetic beauty and the social relations they represent. In Meetings (1999 – 2003) Shambroom photographed the participants and the rituals of civic power, concentrating on the governing boards in small towns of two thousand or fewer people. His most recent series, Security (begun in 2004), depicts training facilities, equipment, and personnel in the massive government and private sector efforts to prepare for and respond to terrorist attacks within the nation's borders. Shambroom employs photographic-based documentary in his long-term investigation into capturing the rarely seen aspects of various places of power.

The connective tissue that bridges the gap between Shambroom's projects is a question about America. Like photographers Robert Frank and Walker Evans before him, Shambroom inquires about how one begins to think about taking a portrait of a nation. Frank attempted to answer the question with his book The Americans, first published in 1958. His photographic tour of the United States took place around 1955 and resulted in a stark and biting series of images of American life: the highway, Fourth of July celebrations, automobiles, and roadside restaurants. Evans, along with writer James Agee, produced the book Let Us Now Praise Famous Men (1941), which poetically and forcefully documented the plight of tenant farmers in the 1930s by producing images of a community at risk.

Similarly, Shambroom engaged in a physical and metaphorical road trip across the nation in a quest to capture the quintessence of the American experience. He has traveled the country photographing factories, town hall meetings, and nuclear weapons sites. Frank's subject matter was broader and his approach was laced with ironic detachment, while Evans's focus was more specific. For Shambroom, it is not so much about discovering some elusive universal essence that is uniquely American, because no one body of images can distill something as idealistic as a nation's identity; rather, it is more a question of constructing a mosaic from a series of individual parts that somehow coalesce to create a fragmented whole.

Issues of representation are not merely hypothetical concerns for Shambroom: they are central to the ways in which we negotiate our relationship to social and political power. For Shambroom, they are embedded, at the most intimate level, in our lived experience of the world and marked with particular social and familial connection. Shambroom's father was a U.S. Navy officer who was photographed at the site in Nagasaki where the atomic bomb had exploded just eight months previous. Paul stated that he "started reading about the psychological environment, thinking about my own motivations. My father was a naval officer who had a personal history directly with nuclear weapons, and all that started to tie in with learning about those things and talking with him. It was valuable in helping me understand why I was so obsessive and interested in nuclear weapons in the first place."[3] It should not be surprising that these early childhood images would have a profound effect on the artist and be a natural extension of his aesthetic and artistic expression. In order to gain a deeper understanding and wider context for the Nuclear Weapons series, we must first understand and review the behind-the-scenes process and motivations for making the pictures.

Shambroom decided to begin this series in the early 1990s after the Soviet Union collapsed and the cold war had officially ended. He began a long and arduous two-year letter-writing and telephone campaign to military officials to request access to sites that were previously closed to the public. With help and letters of recommendation from his Congressional delegation and cooperation from the top public affairs officials of the U.S. Air Force, Navy, and the Pentagon, he was allowed to photograph bombers, missiles, submarines, warheads, and associated facilities throughout the United States. Of the letter-writing process, Shambroom said:

I developed and honed skills of writing letters and being persuasive and trying to anticipate the objections or issues of the people controlling the access. It turned out to be a very valuable skill and one that I ended up kind of enjoying, much to my surprise, because it's basically office and arts administration work — but it's a skill that made the nuclear weapons project possible. It became very, very important that the letter was well crafted, and I would spend hours, sometimes days, writing a single letter. I viewed that as not just background to my art making but *part* of my art making: writing the letter was part of the making of the art. With the Nuclear Weapons project, the fact that I was able to be in these places was a conceptual underpinning for the art itself.[4]

The first site the military gave Shambroom permission to photograph was Ellsworth Air Force Base in South Dakota in 1992. Since then, he has made thirty-five visits to more than two dozen weapons and command sites in addition to hundreds of individual ICBM silos in twenty states. Shambroom put self-imposed restrictions on this project: he gave himself permission to take pictures only of U.S. strategic nuclear weapons and infrastructure current as of the end of the cold war. He wanted to exclude tactical weapons, obsolete or retired weapons, and weapons development, testing, and manufacturing. The project was completed in 2001 just prior to the terrorist attacks on September 11.

Shambroom has created a visual encyclopedia of nuclear weapons sites throughout the United States as he travels the country on the lookout for the most representative images from each site. The result is a technically flawless brand of photographic documentation that synthesizes the histories of social documentary and political art. Shooting in rich color, he frames his subjects in as dispassionate a manner as he can without losing the pathos of the critique. He photographs each site and location as a "found object," documenting everything from the weapons, in glorious shiny detail, to the military personnel cleaning and working around them.

The Nuclear Weapons series is comprised of a variety of photographic themes and subjects. Shambroom photographs a Poseidon submarine officer's pillowcases that depict pictures of his family with the words "we love you." Minuteman II Missile in Transporter Erector Vehicle, Ellsworth Air Force Base, South Dakota (1992; Plate 26) captures the exposed underbelly of a missile, unveiling a normally unseen space; the rocket engulfs an Air Force technician who is working on the missile's engines, his legs protruding from the machine. In another picture, technicians are preparing an Exoatmospheric Kill Vehicle. Shambroom also shows military personnel cleaning, repairing, transporting, and guarding weapons and their storage units.

In other pictures Shambroom photographs in excruciating detail. In the three photographs Commander in Chief of NORAD's (CINCNORAD) seat in Command Center "Battle Cab," NORAD/USSPACECOM Command Center, Cheyenne Mountain Operations Center, Colorado Springs, Colorado (1993), Trident submarine control room, USS Alaska, Naval Submarine Base Bangor, Washington (1992; Plate 20), and Joint Chiefs of Staff Conference Room, National Military Command Center, the Pentagon, Washington, D.C. (1993; Plate 23), his full field of focus provides the viewer with a never-seen-before look behind the scenes. Still, what is revealed in these images are specific moments of day-to-day events, details that are glossed over in the nightly news and weekly magazines. Like dioramas in a history museum, Shambroom's photographs offer views into closed systems and tell us a great deal about the culture of those men and women who inhabit such spaces and environments. A visual sociological experiment, his work explores the power of the social situation and determines the behavior and individual attitudes and values of the military personnel. Collectively, his photographs present a subliminal psychological and sociological study of military power in America.

Shambroom encountered numerous technical and logistical problems at each of the sites, which made the conditions for taking the photographs extremely challenging. His movements were always highly restricted and, for security reasons, military personnel escorted

4 Ibid.

5 Ibid.

6 Ibid.

him through each location. The itinerary for each location was monitored and very strict. Veering from a pre-set itinerary was almost impossible, leaving the chance to respond to new opportunities or locations very difficult. Shambroom often had to agree to have his film processed on the site by a military lab before he left. These labs were not always up to the highest photographic standards, and he often received film back that had been damaged during development. It occurred to Shambroom that the military may want to edit his film for reasons of content, not simply concern over breaches in security, but in ten years only a handful of images were held back because they depicted new technology or instruments considered highly classified.

Several sites, according to Shambroom, had unusual security and technical challenges that made them even more difficult to photograph. Before he could gain access to USSTRATCOM (formerly the Strategic Air Command) Underground Command Center, he had to agree to use only military cameras and equipment and was allowed only to compose the picture; a military escort loaded the film and pushed the shutter. There was a short list of facilities and sites that he was never given permission to shoot, despite repeated requests. These locations, known as the "continuation of government" sites, included the doomsday leadership bunkers at the White House and the Mount Weather "Special Facility" bunker in the Blue Ridge Mountains of Virginia where leading government officials were taken after 9/11. Two of the country's largest nuclear storage facilities in New Mexico and Nevada were also off limits, as well as the weapons disassembly and plutonium pit storage operations at the Pantex Facility in Texas.

The Nuclear Weapons images demythologize outside the concept of truth, yet the series clearly argues for art that is a confrontation of values. It is aggressive in its questioning and asks the audience to participate in such questioning. The reading seems contrary to the expected interpretation of the patriotic. The photographs remind us of the content and intentions of war and war installations. The viewer reads the images via the photographs, which act as evidence and argument.

Shambroom's images begin to illuminate how the possible devastation associated with such military might could be connected to other political realities such as increasing global impoverishment and exploitation, uneven development, racism, and the unchecked rampages of global capital and the militaries that serve it. The effects of Nuclear Weapons in combination with other signs and sources in Security and Meetings make some of the missing connections visible by multiplying the evidence. It's not hard to see why Shambroom went directly from Nuclear Weapons to a project in which he investigated another form of power at the other end of the democratic continuum: meetings of small municipal government and community groups.

The elegance of Nuclear Weapons and its social content become both aesthetically and politically provocative. The style of the work makes its social truth accessible and convincing. Shambroom frames his political discourse in almost purely visual terms. His photographs rely on the power of the single straight image to convey the personal, political, and aesthetic. He said, "I selected these images for their inherent visual power. I always place certain value on artfulness, though never stressing it over the information it helps to convey."[5] In all of the series in this exhibition, he has amplified the purely aesthetic integrity of photographs. Such seamless conflation of image and information serves both his documentary and artistic ends. His work encourages the viewer to claim the importance of art practices, which help us see our environment more critically rather than just provide an escape from it. Shambroom transforms the mundane into subjects of thoughtful meditation: what are seemingly banal images are on reflection full of meaning. The photographs in Paul Shambroom: Picturing Power are emblematic of his work in its idiosyncratic perspective, technical proficiency, and formal beauty.

Shambroom has stated that a persistent thread in his work is an exploration of the manifestations of power. He has also commented that "like many other photographers I wanted to show things that had not been seen before."[6] His concern with the dynamic of visuality and disclosure has been consistent: from the early

Official itinerary for
Paul Shambroom's visit
to F. E. Warren Air Force
Base, Cheyenne, Wyoming,
October 1992.

Itinerary for 5-7 Oct
Paul Shambroom visit
(POC SSgt Rosso, 3381)

(92)

5 Oct - 0800 - Wing mission briefing in WCR

0845 - LV for weapon storage area

→ (0900 - Arrive WSA (TSgt Bradley POC)

1000 - LV for Uniform 01 & 02

1015 - Arrive Uniform 01 & 02 (MSgt Brand POC)

1115 - Lunch

1230 - Museum/Reunion Center

6 Oct - 0615 - LV base

0630 - Arrive (PK) Romeo 6 LF (Gary Smith escort)

0730 - LV for Quebec LCF

0745 - Arrive (PK) Quebec LCF (Gary Smith escort)

0945 - LV for November 10 LF

1030 - Arrive (MM) November 10 LF (Gary Smith escort)

1115 - LV for base

1200 - Arrive at base

7 Oct - 1630 - LV base

1730 - Arrive (MM) Hotel LCF (Lt. Messmer escort)

1900 - LV for base

2000 - Arrive at base

FE Warren 10/92

7 See the Greenpeace
 International web site,
 www.greenpeace.org/
 international/campaigns/
 abolish-nuclear-weapons.

Offices series and the forgotten face of the employers, to the empty factory environments, to nuclear weapons as the measure of destruction that, by definition, is beyond our grasp. Herein lies one of the central paradoxes of his work: the drive to make visible that which is hidden and the simultaneous recognition that the process of exposure will, inevitably, destroy that which it seeks to reveal.

Today, the number of countries with active nuclear weapons programs is increasing. More nations are lining up to join the nuclear club, making it more likely that a nuclear catastrophe will happen somewhere on the planet. The first concrete result of George W. Bush's war on Weapons of Mass Destruction was North Korea's announcement that it had built "enough nuclear weapons to deter a U.S. attack,"[7] thereby increasing the number of countries with declared nuclear weapons from seven to eight. Shambroom's photographs brim with political implications, indicting the United States' current political posture and rightist government complacency in world power. His work challenges the historical amnesia of contemporary culture and points to the complicity of the artist in maintaining this condition. Rather than demonstrate an aesthetic based on isolation of a formal visual experience, the photographs of Paul Shambroom elaborate an aesthetic knowledge designed to comprehend and embody the complex interconnection between the visual, the cultural, and the political.

——

Christopher Scoates is director of the University Art Museum, California State University, Long Beach. His curatorial projects during the past twenty years have addressed such issues as homelessness, neocolonialism, gender, and identity politics. His writings have been published in New Art Examiner, Sculpture, and Art Papers magazines.

NEITHER TO CRITICIZE NOR GLORIFY PAUL SHAMBROOM'S STUDIED NEUTRALITY

HELENA RECKITT

1 Paul Shambroom, <u>Face to Face with the Bomb: Nuclear Reality after the Cold War</u> (Baltimore: The Johns Hopkins University Press, 2003), xi.

2 Ibid., xiii.

Although apparently opposites, vigilance and apathy operate in shared obscurity in Paul Shambroom's photographs. We are barred entry to the installations in <u>Nuclear Weapons</u> and we prefer to let others attend to the procedures in <u>Meetings</u>. Depicting these polarized institutions with his trademark quasi-clinical objectivity, Shambroom captures revealing details of, and intriguing connections between, these little-seen loci of power.

He developed his stance of studied impartiality in 1990 when seeking permission to photograph America's nuclear arsenal. "My intention is neither to criticize nor glorify nuclear weapons," he wrote to Navy and Air Force officials requesting their cooperation. To Shambroom, nuclear bombs represented "the ultimate in power" and gaining access to depict them and show what was hidden "the ultimate professional challenge,"[1] requiring the diplomacy, persuasion, and patience more often associated with doing business than with making art.

Shambroom was not the first photographer to attempt to depict the world of nuclear weapons. Robert Del Tredici had documented the entire nuclear cycle, from uranium mines through processing and manufacturing facilities, to weapons sites and nuclear waste dumps, for his project <u>At Work in the Fields of the Bomb</u> in 1987. But no one had attempted the systematic photographic survey of America's nuclear weapons' infrastructure that Shambroom intended. Yet despite the time demanded to negotiate with the Defense Department, and the secrecy that had surrounded nuclear weapons, Shambroom suspected that his project might succeed. As the cold war ended and the Soviet Union collapsed, the military faced pressure to reduce its nuclear arsenal. Threatened with budget cuts, Defense Department officials might well see Shambroom's proposal as an opportunity to show taxpayers that they were getting value for their money, to demonstrate the importance of nuclear deterrence, and to emphasize the need for continued funding.

After extensively researching nuclear weapons and military processes (including such niceties as grasping the difference between unseen and classified information), Shambroom requested access to deployed strategic nuclear weapons and infrastructure that secrecy laws did not cover. Eventually his instincts proved right. In September 1991, after having rejected several earlier requests, the Navy approved his project as "an ideal way for the American people to see the complex and highly technological environment in which submariners work."[2] Using this permission as leverage, Shambroom wrote again to the Air Force, which had ignored his earlier letters. Within a month the Air Force, too, granted his request. Consequently, as a result of continued requests, from 1992 until the events of 9/11 put an end to the project, Shambroom gradually received unprecedented access to photograph nuclear defense facilities in the United States. He visited thirty-five military bases (plus hundreds of individual intercontinental ballistic missile silos) in twenty American states and in the South Pacific, photographing bombers, missiles, submarines, warheads, nuclear facilities, and their personnel.

Shambroom's letter of introduction elided his opposition to nuclear weapons, and his photographs live up to his promise of neutrality. His elegant views of missiles and bases in <u>Nuclear Weapons</u> and the accompanying book, <u>Face to Face with the Bomb: Nuclear Reality after the Cold War</u>, let the viewer judge whether nuclear weapons are valuable deterrence or dangerous extravagance. Suppressing Shambroom's subjectivity, the images betray neither the sense of horror he might have experienced in documenting weapons of mass annihilation nor his resistance to American defense policies.

The calm professionalism of a work such as <u>Ohio class Trident submarine USS Alaska in dry dock for refit, Naval Submarine Base Bangor, Washington</u> (1992; Plate 19), depicting the massive vessel being serviced, would be appropriate in a Defense Department journal or the annual inventory of military vessels, <u>Jane's Fighting Ships</u>. Shambroom's notes in <u>Face to Face with the Bomb</u> include the submarine's length (560 feet), weight (18,750 tons submerged), and cargo (twenty-four multiple warhead missiles), feeding the appetite for details that we would expect from a military specialist (which Shambroom became) or enthusiast (which he did not).

1607 Dupont Avenue North
Minneapolis, MN 55411
(612) 521-5835

August 24, 1990

Rear Admiral Brent Baker
Chief, Office of Information
Department of the Navy
The Pentagon, Room 2E-340
Washington, DC 20350

Dear Admiral Baker:

I am an artist and photographer living in Minneapolis. The following request for assistance was originally made through my Congressman, Representative Martin Olav Sabo, Minnesota 5th District, who suggested I direct it to your attention.

I wish to undertake a photography project that would involve photographing the interior workplaces of the delivery systems of the U.S. strategic nuclear arsenal. The enclosed "Artist's Proposal" explains the idea in further detail. It states, in part: "The main theme I wish to explore is the demystification of areas of hidden power.... My photographs of these areas will not be strictly documentary in the sense of describing the hardware of nuclear weaponry. Nor will they be meant to criticize or glorify. My intention is to present areas that have existed only as powerful concepts in our collective consciousness, in a way that viewers can relate to their own realities."

Enclosed, you will find a resume and copies of letters of recommendation from Peter Galassi, of the Museum of Modern Art in New York, and Carroll T. Hartwell of the Minneapolis Institute of Arts.

The photographs would be shown and published in a fine art context, such as museums, galleries, and art books. I am currently working on a Photography Fellowship from the McKnight Foundation/Film In The Cities. I am confident that further funding can be obtained from similar sources if I am able to proceed with the project.

I would like to photograph at least one site of each leg of the strategic weapons triad: submarines, ICBMs and long-range bombers. I would prefer to work at sites that have the most modern weapons systems in place, because these would better fit my stated goal of photographing areas of "hidden power." In the Navy's case, this would be the Trident submarine. I would, of course, be able to work with older Poseidon submarines if the Tridents were not possible. I do not have information on basing sites for these systems, so I cannot be more specific in requesting particular locations at this time.

Initially, I would request one or more days to photograph at each site. I would mostly be interested in the areas where the weapons are actually deployed, although not necessarily the weapons themselves. I would prefer to photograph submarines when they were operational (at sea), although I realize this would be extremely difficult to arrange. I could certainly accomplish my goals photographing a submarine in port, as well.

My photographs are generally of rooms and spaces, and do not concentrate on people. I am aware that security considerations may require that personnel not be identifiable, and I am able to work around that, if necessary.

If dictated by your security requirements, I would be willing to give you approval rights on all pictures before they would be released.

I have had a great deal of experience photographing in high security environments, both for my fine art work and for commercial clients. In the former category, I have shot at the Rockwell Space Shuttle Assembly plant, Hughes Aerospace, and McDonnell Douglas Astronautics plants, all in the Los Angeles area, Boeing, in Everett, WA, as well as Texas Instruments missile production and Bell Helicopter in Texas. My commercial jobs have taken me to Cray Research, Honeywell Ordnance factories, and the NASA research facility in Langley, VA. Cray Research, in particular, has been a long-standing client, and I'm sure their upper management would provide a letter of recommendation if requested. It may also help to note that I have received Secret Service clearance for magazine assignments on several occasions, most recently for the Soviet President Gorbachev's visit to Minnesota.

You may note that my Artist's Proposal also mentions a desire to photograph Soviet nuclear arms facilities. I intend to address this seemingly impossible task after I have made some progress with the U.S. facilities. Things seem possible today that I wouldn't have dreamed of six months ago.

While I am no better at predicting the future than anyone else, I believe and hope that the world wide changes we are currently seeing will permanently reduce today's level of nuclear readiness. This possibility adds to my conviction that today's nuclear weapons capabilities should be artistically interpreted and recorded for future generations.

Sincerely,

Paul Shambroom

(enc.:4)

3 Ibid., xv.

4 Robert Jay Lifton and
 Richard Falk, Indefensible
 Weapons: The Political
 and Psychological Case
 against Nuclearism (New
 York: Basic Books, 1982),
 11.

5 Robert Hirsch, "Paul
 Shambroom: Face to
 Face with the Bomb,"
 Afterimage (May/June
 2004); included on
 paulshambroomart.com.

6 See Iain Boal, T. J. Clark,
 Joseph Matthews, and
 Michael Watts, Afflicted
 Powers: Capital and
 Spectacle in a New Age
 of War (London: Verso,
 2005).

7 Robert Del Tredici, "We
 live so others may die,"
 Los Angeles Times,
 August 3, 2003; included
 on paulshambroomart.
 com.

8 Bob Mielke, "An
 Unprecedented View into
 the Abyss," amazon.com,
 June 12, 2003.

9 "Featured in Mr.
 Shambroom's book,"
 amazon.com, August 19,
 2003.

Peacekeeper missile W87/Mk-21 Reentry Vehicles (warheads) in storage, F. E. Warren Air Force Base, Cheyenne, Wyoming (1992; Plate 29) shows a row of hooded bombs, defended like so many crown jewels by an armed guard facing away from us at the picture's vanishing point. B83 one-megaton nuclear gravity bombs in Weapons Storage Area, Barksdale Air Force Base, Louisiana (1995; Plate 18) presents a glistening diagonal line of nuclear gravity missiles denoting efficiency, expense, and technical sophistication. They also seem remarkably small for bombs that constitute, the notes tell us, America's most powerful weapons. These notes could support just as easily as criticize nuclear deterrence, although their directness would not pass muster in military circles. "Words such as *bomb* and *warhead* are rarely used," remarks Shambroom. "I was sharply corrected the first time I referred to the MX missile and told that the official name is 'Peacekeeper.'"[3] The technician in fatigues who sweeps the floor beside the bombs introduces a disconcertingly domestic touch. Minuteman III missile silo, "India 8," Ross, North Dakota (1995; detail of Plate 22) also captures this state of coexistence with the bomb. A disturbing example of landscape photography, the image depicts a missile launch facility in the snow-crusted fields, a site that would make locals instant targets in an atomic war.

VISUALIZING THE UNTHINKABLE

The psychologist Robert Lifton has defined the feelings of dread mixed with anticipation toward nuclear war as "nuclearism." In an environment in which people believe that "weapons systems have so expanded, technologically and bureaucratically, that no one person or group has the capacity to control them completely,"[4] this perceived inevitability can be dangerously self-fulfilling. At the core of nuclearism lies our difficulty in visualizing atomic weapons and their effects. Shambroom's clinical documents of nuclear weapons stockpiles try to counter this crisis of imagination by making the unthinkable visible. Face to face with the bomb in Shambroom's work, we see that atomic bombs look disconcertingly like other bombs, and we can be in no doubt about their existence, post–

cold war rhetoric notwithstanding. "Because we have seen the pictures, we know there are still five hundred missile silos with people sitting in them with their fingers on the button. There are over a dozen submarines, fully armed with nuclear weapons, on patrol in the oceans just as they were twenty and thirty years ago."[5] Recent events, from the U.S. invasion of Iraq for possessing Weapons of Mass Destruction that turned out not to exist to the branding of Iran and North Korea as part of an "axis of evil" for their nuclear arms programs (and the accompanying silence about Israel's), make U.S. hypocrisy all too clear.[6]

Yet the ambiguity toward nuclear weapons conveyed by Shambroom's photographs has encouraged widely divergent interpretations. Robert Del Tredici lauded the book's ability to "lull viewers with the homegrown, then stir in the terror."[7] Also convinced of its critical power, an amazon.com reader remarks: "This coffee table volume from hell gets under your skin; these images have entered my dreams. . . . This is what lies under the rock of the national security state. We pay for it; thanks to Paul Shambroom, you can see what you're buying into."[8] Another amazon.com reviewer, under the title "Featured in Mr. Shambroom's book," offers a strikingly different response:

> It was an honor to have him among us as we performed our daily duties. We are not people of evil, we are all Americans bent on protecting our homeland from all who wish to destroy her . . . No one loves nuclear weapons. Not even us who work with them. But the cat is out of the bag and we have to live with our decisions and support our fellow Americans.[9]

The insistent neutrality of Nuclear Weapons contrasts with Shambroom's more ironic tone in earlier projects. Offices (1989–90) depicts corporate culture's sterility with the socially satirical eye that recalls Shambroom's friend and mentor, the British photographer Martin Parr. Like Factories that preceded it, Offices stemmed from Shambroom's commercial photographic work for industrial and high-tech companies, a background that gave him firsthand insights into corporate self-presentation. The experience also

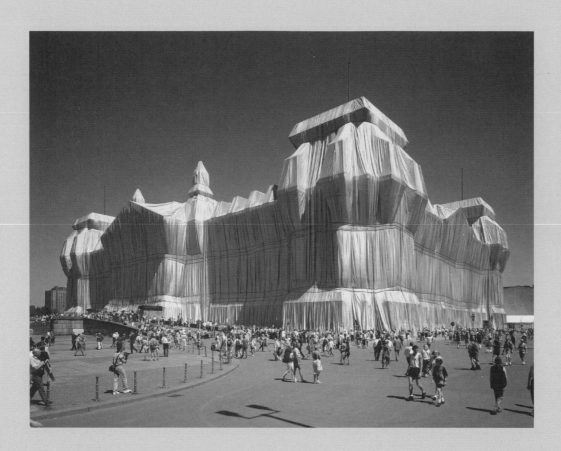

Christo and Jeanne-Claude,
Wrapped Reichstag, 1972 – 95,
Berlin.

10 Conversation between Paul Shambroom, Diane Mullin, Helena Reckitt, and Christopher Scoates, July 12, 2006.

11 Ibid.

12 Telephone conversation between Helena Reckitt and Paul Shambroom, February 8, 2007.

13 Shambroom, Face to Face with the Bomb, xiv.

14 Ibid., xvii.

15 Conversation between Shambroom, Mullin, Reckitt, and Scoates, July 12, 2006.

convinced Shambroom that he could find ample evidence of American domination and globalization's effects close to home. "It was partly a reaction to the idea that photographers were supposed to go elsewhere in the world and report on what they saw and bring it back as a sort of treasure, which always struck me as being a form of cultural colonialism."[10] As a result, Shambroom abandoned the rather aimless street photography he had been pursuing and began to work on hidden-in-plain-sight loci of power: factories, corporate offices, and police stations. "I felt kind of smug and clever. Okay, you guys can go to Africa, you can go to Mongolia, I'm going down the street to photograph the jungle behind the factory wall."[11]

MIRRORING THE MILITARY

Working on Nuclear Weapons would, Shambroom realized, entail surrendering much of the artistic autonomy that he valued. More than just the series' themes, power and powerlessness, activity and passivity also encapsulate Shambroom's experience creating it. Most visits to photograph for perhaps one afternoon required months — sometimes years — of liaison. Shambroom estimates that during some years he took photographs for no more than four days, and he "developed a sense that I was making art when I was sitting at my desk, writing letters, and going to the library . . . it felt workman-like."[12] He brought lightweight equipment to defense facilities in order to avoid unnecessary security checks. A public affairs escort accompanied him and determined which areas he could photograph without revealing classified information. Shambroom's negatives were sometimes processed on site (much to his chagrin) and his images vetted for classified information. On one occasion, at a USSTRATCOM Underground Command Center, Shambroom didn't even take his own photographs: after setting up a shot, he handed the shutter cable to his military escort, an Air Force photographer, who loaded and unloaded it and released the shutter at Shambroom's request.

Shambroom's photographs are negotiations reflecting military concerns and conditions as much as his perspective. This immersion in military culture made Shambroom question his formerly antagonistic attitude toward the institution. Rather than view the Defense Department as homogeneous, he realized that its employees had varying attitudes toward the technology under their watch. Some military escorts expressed their support for the rights of demonstrators outside nuclear bases. Others shared their frustration with Shambroom about the military's lack of transparency.[13] "I could not do the work that they do," Shambroom has stated, "but I have grown to respect them and the choices they have made. I'm sure they believe they are doing the right thing for America."[14]

Rather than rail against the conditions imposed on him, Shambroom recognized that he would have to embrace them if he was going to stay the course. Adopting a "Zen-like mentality," Shambroom recalls how "I learned not to get angry. People told me 'no' all the time and some people were very dismissive or obstructionist — I had to love them rather than hate them and figure out a way to take the 'no' and turn it around into a 'yes.'"[15]

A valuable precedent came from Christo and Jeanne-Claude, who view the prolonged negotiations preceding their projects as a part of their art. While their wrapped structures and environments have little formal connection to Shambroom's photographs, the place of negotiation in the artists' work provides an interesting link, as does the metaphor of veiling/unveiling institutional structures. Just as Wrapped Reichstag (1972 – 95) in Berlin (which resulted from twenty-four years of meetings with German, French, Soviet, and U.S. authorities, culminating in a vote at the German Bundestag) gives a snapshot of global politics during that period, so Shambroom's exchanges with the military offer a glimpse into U.S. policies after the cold war. The ability of Christo and Jeanne-Claude to bring to the table politicians, business people, and artists impressed Shambroom, both for how these sessions exposed the processes behind artworks and for their ability to capture the public's imagination. Shambroom also shares the desire of these artists to reach a broad public. For example, Richard Rhodes, a historian of atomic weaponry, rather than an art writer, contributed the essay introduction to Face to Face with the Bomb, which probably

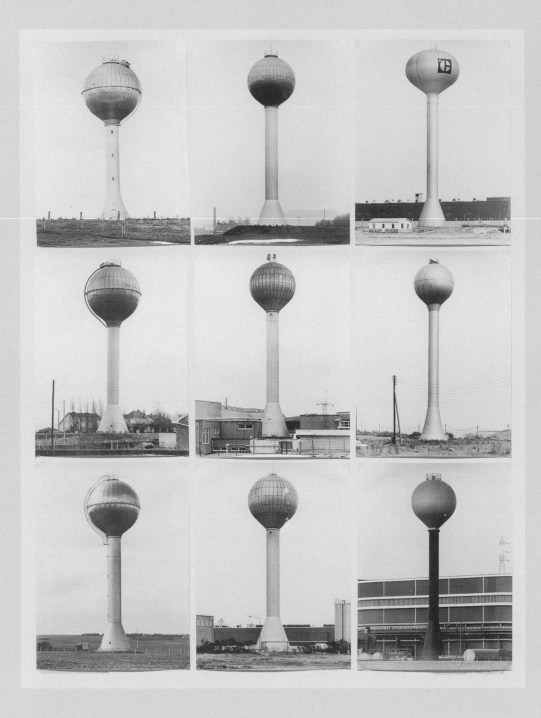

Bernd and Hilla Becher,
Wassertürme (Water Towers),
1972.

16 Walter Benjamin, "A Short History of Photography" (1931), cited in Kim Sichel, From Icon to Irony: German and American Industrial Photography (Boston: Boston University Art Gallery, 1995), 7.

17 Lewis Baltz, review of The New West by Robert Adams (1974), cited in Sichel, From Icon to Irony, 10.

18 Bernd and Hilla Becher, "A Conversation with Jean-François Chevrier, James Lingwood, and Thomas Struth" (1989). Reproduced in David Company, ed., Art and Photography (London: Phaidon Press, 2003), 232.

19 Cited in Bob Nickas, "John Miller," ArtForum (April 2004).

enhanced the book's strong sales outside the art world. Shambroom has also occasionally exhibited in non-art venues such as the Atomic Testing Museum in Las Vegas.

FOR THE RECORD

The idea Shambroom shares with Christo and Jeanne-Claude that their work mirrors institutions links them to the tradition of "objectivity" in documentary and art practices, a history that includes early uses of the camera as a tool for classification and regulation for legal, scientific, anthropological, and other purposes. In the 1920s, German New Objectivists like Albert Renger-Patzsch and Karl Blossfeldt drew on the camera's descriptive abilities to produce deadpan depictions of urban and industrial settings (in Renger-Patzsch's case) and botanical life (in Blossfeldt's). While highly influential, their work also had its critics. Walter Benjamin, for instance, criticized Renger-Patzsch for "transforming even abject poverty, by recording it in a fashionably perfected manner, into an object of enjoyment."[16]

In the 1970s, New Topographics photographers such as Robert Adams, Lewis Baltz, and Stephen Shore honed this austere aesthetic. Drawing on nineteenth-century topographical photographs, Baltz created deadpan images of new housing developments and corporate buildings that eschewed political comment. While claiming that "the ideal photographic document would appear to be without author or art," Baltz recognized even the most seemingly anonymous photograph was a construct, adding, "Yet of course photographs, despite their verisimilitude, are abstractions; their information is selective and incomplete."[17] In 1977 the photographers Larry Sultan and Mike Mandel deepened the exploration of the document with Evidence, a book and exhibition of photographs culled entirely from corporate, government, educational, medical, and technical institutions' files.

A forerunner to these ideas of objectivity, and a major influence on Shambroom, is the photographs that Bernd and Hilla Becher have taken since the late 1950s of houses and industrial buildings. The Bechers' artfully artless style, achieved with a large-format camera, diffused

lighting conditions, and consistent frontal camera position, embodies an ethics of objectivity. "You cannot afford to judge what is good and what is not," says Hilla Becher about their approach. "There's a kind of morality that you have to put aside if you want to be democratic about it and not to judge before you have experienced it ...you have to force a kind of neutrality."[18] As teachers at Düsseldorf's Kunstakademie, the Bechers influenced a generation of photographers (including Andreas Gursky, Candida Höfer, Axel Hütte, Thomas Ruff, and Thomas Struth) whose detached, detailed works follow the conventions of objectivity. Yet the Bechers' work originally moved beyond the interests of architectural historians into the art world through the enthusiasm of minimalist sculptor Carl Andre for its unadorned, systematic style.

This relation with minimalism and its conceptualist outgrowths — with their shared interests in corporate and institutional culture, systems, record-making, and photography as a descriptive tool — suggests potentially intriguing connections with Shambroom's work. Yet Shambroom's approach to graphic and linguistic data differs from that of conceptual artists. Where Shambroom regards the letters, maps, databases, and minutes that he produces as interesting but supplementary materials, conceptual artists like Conrad Atkinson, Hans Haacke, and Mary Kelly often incorporate such information into their art as means to investigate ideological values. Shambroom's faith in the power of the photographic archive also diverges from that of conceptual artists who undermine the impulse to classify with a sense of the absurd. Douglas Huebler, for example, proposes his quasi-Mormon attempt to "photographically document, to the extent of his capacity, the existence of everyone alive" in his Variable Piece No. 70 (1971).[19]

The most important distinction between Paul Shambroom's work and that of conceptual artists concerns notions of photographic truth. Without getting mired in debates on "authenticity," Shambroom has claimed: "I feel no need to follow the conventions of the 'documentary police,' and in fact I would be fired if I tried to present my work in a photojournalistic context. That said, I have my own standard for what is

Douglas Huebler, <u>Variable Piece No. 70 (in Process), May 10, 1976</u>, 1976.

20 Joerg Colberg, "A Conversation with Paul Shambroom," Conscientious weblog, December 6, 2006; included on paulshambroomart.com.

21 Blake Fitzpatrick, "At Work in the Fields of the Bomb," Fuse Magazine 27, no. 3 (September 2004).

22 Allan Sekula, "On the Invention of Photographic Meaning," in Allan Sekula, ed., Photography against the Grain: Essays and Photo Works, 1973–1983 (Halifax: The Press of the Nova Scotia College of Art and Design, 1984), 3.

23 Michael Fallon, "How Does Democracy Look?" Art Papers (November 2004); included on paulshambroomart.com.

true: Would the people in the photograph look at it and agree 'Yes, this is what this experience, this moment, this place was like?'"[20] So Shambroom sees Nuclear Weapons as a photographic archive with serious, albeit subtle, political ambitions.

Yet archives' open-endedness makes them available to a range of uses. Blake Fitzpatrick demonstrates this point in his discussion of images by Robert Del Tredici that the U.S. Department of Energy published in its reports and stripped of critical intentions in the process.[21] Allan Sekula has written on the myth of objectivity that has surrounded photography since its invention, urging skepticism toward visual and other messages that "are spoken with the voice of anonymous authority and preclude the possibility of anything but affirmation."[22] Shambroom engages in a complex and multivalent way with debates on photographic evidence. Although invested in concepts of visual proof, his photographs' assumed neutrality subtly exposes institutional values.

POWER TRIPS

"Command, Control, and Communications (C³)," the fourth section of Face to Face with the Bomb, depicts command centers, control rooms, and detection and warning systems devices. Perhaps more than anything else in the Nuclear Weapons series, these pictures capture our fears about nuclear weapons: who's in charge, and what if things go wrong?

Systems of communication and interconnectivity have long featured in Shambroom's work, from the geometric pipes and tubes prevalent in Factories to the mounds of phone and computer lines under floor panels in Offices. As Nuclear Weapons wound down, he decided to develop his investigation into sites of decision-making with a new series. Having become rather cocky about his negotiating prowess, he was surprised when corporations with no responsibility to make their meetings public rejected him. Consequently, he switched his focus from the most influential forms of power brokerage to those representing the smallest increment of elected governance: local council meetings.

This shift appealed to Shambroom for several reasons. After the labyrinthine negotiations

of Nuclear Weapons, he relished the lack of red tape in photographing public assemblies, although he did contact councils in advance and introduced his "study of representative democracy in action" at each meeting. Only once was he prevented from photographing a meeting. In a nice reflexive touch, Shambroom's presence often appears in the minutes, some of which were reproduced on onionskin in the publication for this series, Meetings. By homing in on small towns (of two thousand or fewer people), he pinpointed strong regional differences that survive in an increasingly homogeneous world. The improvised spaces where councils meet especially attracted him, with state and U.S. flags proudly displayed or casually propped up against walls, blackboards and art projects hinting at the rooms' regular uses, and makeshift furniture that often matched the casual attire of the people in the photographs. Describing his first visit to a small-town council meeting, Shambroom recalls, "I walked into the room and I thought wow, this is something. They were all lined up, and I loved the linear layout. They were sitting at a table in the front of the room, very engaged, and the set up was beautiful. I realized the way to do this was not to be clever, just put a camera in the middle and let subjects make their own photographs."[23]

Meetings gives a glimpse of American demographics, from the mixed-race assembly of stressed-out men in the economically stretched Florida town of Pahokee, to the suggestion of a growing African American power base in Wadley, Georgia (population 2,468) City Council, August 13, 2001 (Plate 34), where one white and three black men gather under portraits of one black and three white men. Women's grassroots involvement emerges strongly. Dassel, Minnesota (population 1,134) City Council, March 15, 1999 shows four serious-looking white women listening to an unpictured citizen, all but one (with her travel mug) accompanied by a different variety of Coca-Cola: Classic, Diet, and Diet caffeine-free. In Dobbins Heights, North Carolina (population 936) Town Council, November 8, 2001 (Plate 30), the African American female officials, together with one recorded citizen, meet, following a reading of Thank God for Little Things, to consider issues

Leonardo da Vinci, <u>The Last Supper</u>, 1498.

Computer mapping program linked to Paul Shambroom's database of 15,000 communities, showing meetings that take place on the second Monday of the month in Georgia.

24 Paul Shambroom, _Meetings_ (London: Chris Boot Ltd., 2004), unnumbered.

25 _Regarding the Rural_, MASS MoCA (Massachusetts Museum of Contemporary Art), North Adams, Massachusetts, September 24 – December 31, 2005.

26 Maren Stange, "The Record Itself: Farm Security Administration Photography and the Transformation of Rural Life," in _Official Images: New Deal Photography_ (Washington, D.C.: Smithsonian Institution Press, 1987), 3.

27 Shambroom, _Meetings_.

of sanitation, street repairs, fire safety, census reports, sales tax, double parking, illegal dumping, and the preponderance of leaves in the park. Along with recording the economic and administrative challenges faced by communities around the country, the minutes also reflect council secretaries' varying styles, from terse reports condensing lengthy debates into one line to the unintentionally amusing verbatim account from Pahokee, Florida, that includes Commissioner Branch's verdict: "WE CAN'T PAY OUR BILLS FOLKS AND I JUST WANT EVERYBODY IN THIS CITY TO KNOW IT." [24]

As in _Nuclear Weapons_, Shambroom approached his subject systematically. In a pre-Mapquest age, he devised a database that organized his itinerary according to meetings' schedules and region. This itinerant form follows the tradition of the road trip, an approach that attracted artists from Walker Evans to Robert Frank, Jack Kerouac to Stephen Shore, and included such conceptual adaptations as Tony Smith's epiphany while taking a nocturnal drive on the unfinished New Jersey turnpike, Robert Smithson's _Tour of the Monuments of Passaic, New Jersey_ (1967), and Catherine Opie's 2001 _Domestic_ photographs of lesbian households throughout America. Just as the road trip often records ways of life that are dying out, the melancholic undertone of _Meetings_ evokes the ritual of local democracy as valuable yet vulnerable. In contrast to the outsider status generally assumed by the artist traveler, _Meetings_ has none of the romance of the road typically associated with the genre. Instead, its consistent form comes across as an archive of small-town democratic processes.

By manipulating color and composition in his seemingly straight images, Shambroom draws out connections with traditional portraiture and history painting as well as cinema. The panoramic format of the series echoes Leonardo da Vinci's _The Last Supper_, and Shambroom plays up _Meetings_' painterly qualities by inkjet printing on canvas that he varnishes, stretches, and frames without putting under glass. His need to photograph these local leaders in repose, in order to avoid blurring, gives them a theatrical quality that he heightens by toning the portraits so that

they pop against the background. Depicting the officials but not the audience leaves open the question of how many citizens actually attended. Through these techniques _Meetings_ both ennobles and affectionately satirizes its subjects, imbuing them with gravitas that often conflicts with the mundane issues under discussion — what Shambroom, referring to the 1996 comedy about a small town's sesquicentenary, calls its _Waiting for Guffman_ moments.

Photographs from _Meetings_ were included in _Regarding the Rural_, an exhibition that contextualized the work of contemporary artists in relation to the Farm Security Administration's renowned photographic archive. [25] Publicizing the plight of the rural poor, especially in the South, the FSA aimed to generate support for Roosevelt's New Deal program of rural assistance. Its most famous photographs, like _Migrant Mother_ by Dorothea Lange, promoted an aura of noble stoicism in the face of hardship that denied rural workers' political consciousness and activism. As Maren Stange attests, "few images in the file show workers' organized responses to the generally wretched conditions of agricultural production … the details of exploitation and resistance that might dramatize the emergence of a new consciousness among former farmers appear only piecemeal and by chance." [26] As _Regarding the Rural_ made clear, Shambroom's depictions of rural self-governance contrast strongly with the FSA's stoic images, while the matter-of-fact approach and humorous undertones protect the photographs from sentimentality.

The publication for _Meetings_ opens with an extract from Alexis de Tocqueville's _Democracy in America_ (1835), including his description of local assemblies in New England as "a field for the desire of public esteem, the want of exciting interest, and the taste for authority and popularity." [27] Capturing these mixed motives for political participation, Shambroom gently indicates the vanity and self-satisfaction that can motivate community service. The absence of strong moralizing in _Meetings_ allows viewers to see it as reflecting their own attitudes toward power and democracy. Like _Nuclear Weapons_, the series has attracted a range of interpretations. In the exhibition

Robert Smithson, <u>Monuments of Passaic (The Bridge Monument Showing Wooden Sidewalk)</u>, 1967.

28 John Q. Public & Citizen Jane: Private Americans in the Public Domain, University Art Gallery at San Diego State University, San Diego, California, January 29 – March 7, 2007.

29 Alan Gartner, "Shambroom's bleak view of U.S.," Chicago Tribune, November 6, 2003, p. 3; included on paulshambroomart.com.

30 Conversation between Shambroom, Mullin, Reckitt, and Scoates, July 12, 2006.

John Q. Public & Citizen Jane, selections from Meetings showed alongside polemical work by artists such as Martha Rosler and Allan Sekula as tributes to everyday democratic processes and community empowerment.[28] Presented in tandem with Nuclear Weapons, Meetings might suggest that more time spent in open discussion could have prevented the impasse of nuclear proliferation. Yet a critic reviewing an exhibition including works from both series read them as indicting the lack of real democracy in the United States: "the two series, when taken together, present an America that is a wasteland, almost unremittingly bleak … The people in his pictures are fiddling while the world is about to burn."[29]

Acknowledging his photographs' susceptibility to multiple interpretations, Shambroom would not have it any other way. Ultimately he sees the aesthetics of neutrality as both more formally successful and more ethically respectful than those of overtly political art. As he has remarked, "I go to peace demonstrations, but I leave my camera at home."[30]

———

Helena Reckitt is senior curator of programs at The Power Plant Contemporary Art Gallery in Toronto. She was formerly director of exhibitions and education at the Atlanta Contemporary Art Center. She is editor of Art and Feminism and coeditor of Acting on AIDS: Sex, Drugs, and Politics, and has published in Art Papers, The Guardian, C Magazine, n.paradoxa, and Art Asia Pacific. She worked at the Institute of Contemporary Art in London and was commissioning editor for film and performance studies at Routledge.

BAFFLING LIGHTS PAUL SHAMBROOM'S SECURITY SERIES

DICK HEBDIGE

1 From interview with Paul Shambroom by Marianne Combs, "Picturing Security," Minnesota Public Radio, September 21, 2006.

2 Stephen Graham, "Theme Park Archipelago: Simulating War in an Urbanizing World," Department of Geography, Durham University, unpublished paper, 1. http://www.geography. dur.ac.uk/information/ staff/personal/graham/ graham_documents/ DOC%204.pdf.

I remain very concerned about what we are not seeing.
— FBI director Robert Mueller, February 16, 2005, testifying before the Senate Committee on Intelligence on the nonoccurrence of terrorist attacks in the United States since 9/11

While a subject of concern for artists and metaphysicians since time immemorial and a leitmotif for U.S. counterintelligence at least since the cold war (viz., the CIA–KGB's "wilderness of mirrors"), visuality and its limitations is not a topic one would imagine J. Edgar Hoover, for instance, losing much sleep over. It is then symptomatic of the deeply irreal atmosphere prevailing in twenty-first-century America that the head of the FBI could feel licensed to kvetch onto the public record not about the proliferation of jihadist atrocities on U.S. soil but rather the total lack thereof in the years since 9/11. The Home of the Free, inviolable no longer, seems today simultaneously oblivious, hypervigilant, and in an advanced state of shock, committed to doing business as usual yet stricken with anxiety: locked in a state of permanent preparedness. As affluent as ever (if massively in debt), still publicly demanding the best yet secretly expecting the worst, the nation chugs along haunted in the suburbs and the small towns as much as at its edgy D.C. center by its own projections of disaster and reprisal.

It is this literally uncanny scene — the familiar world made weird, the everyday undone at every turn by the prospect of catastrophe — that Paul Shambroom explores to quietly devastating effect in his Security series. At once an elaboration on and a synthesis of earlier work (Nuclear Weapons and Meetings), these large 63 x 38-inch photographs explore the mundane melodrama of a democracy engaged in deadly simulated combat with its own worst nightmares: nuclear, chemical, and biological attacks, improvised explosive devices, hostage takings, toxic train derailments, pestilence, plague, flood, and fire. In these recent photographs Shambroom completes his grounded ethnographic examination of American power and citizenship through a merger of the tropes of doom and public service developed in the earlier series. Here first responders and emergency workers (firefighters, police, paramedics, and bomb disposal, biochemical, and toxic materials cleanup units) battle disaster scenarios in simulated "real-life" settings.

The domestication of the Apocalypse is in the end a singularly American enterprise as predictable in its way as suburban megachurches, Internet porn, and reality TV. Shambroom remains as always resolutely ambivalent if not neutral in his presentation of this, the latest sincerely enacted pyrotechnic performance in the apocalyptic drama of American becoming. To use his own words, he is intrigued by "the intersection of fear, comedy, and noble intentions" evident within the scenes of faked calamity he photographs.[1]

Abby Niles volunteered her Saturday to play an accident victim. Volunteers wear tags that list their symptoms and injuries. Niles' tag said she had a foreign object penetrating her chest and she was panicky. [Texas Engineering Extension Service (TEEX) spokesman Jason] Cook said it was once a struggle to encourage people to come out and play victim, but now they are turning volunteers away or putting them on waiting lists.
— www.theeagle.com

The disaster simulation and security industries are of course by no means purely home-based. According to Stephen Graham, an "archipelago of between 80 and 100 mini cities is rapidly being constructed across the world" by the U.S. military-industrial-entertainment complex.[2] This emergent archipelago buried deep within domestic military bases — but also sited in the hinterlands of Kuwait, Israel, rural Britain, Germany, and the islands of Singapore — is the two- and three-dimensional product (some of these "cities" are virtual, digitized environments) of what Graham dubs the "military simulacral collective," an ad hoc consortium of U.S. military personnel, military contractors, theme park designers, Hollywood special effects experts, universities, and video game specialists. These phony conurbations, many permanently populated by Arab-speaking Iraqi and Afghani extras, reinforced where necessary by bearded, turbaned

Steve Rowell, _Playas sits and waits for its day in the sun_, 2005. Center for Land Use Interpretation.

3 Richard J. Norton, "Feral Cities," Naval War College Review 56, no. 4 (Autumn 2003).

4. "Life and Times," KCET, January 3, 2007.

5 Shambroom interview with Combs, "Picturing Security," Minnesota Public Radio, September 21, 2006.

U.S. grunts, mimic what Richard Norton has described as the "feral" cities of the global south (e.g., Baghdad), the "battlespace" singled out by western military advisors as the twenty-first century's most strategically important "theater of war."[3]

As America's own urban centers atrophy or are hollowed out by developers and converted into pedestrian retail and loft-living enclaves, old-style organic urbanism and urban culture get reclassified as archaic and residual, hence "un-American." Haphazard, unhygienic, hetero-geneous, the city of the global south is refigured from the more manicured vantage point of the burgeoning U.S. suburb, the exurb, or the video game console not as a space to be inhabited but as a dissident Orientalized object to be occupied, subjugated, and reformed. Simulated Middle Eastern cities erected on U.S. bases like Twentynine Palms north of Palm Springs ("If you didn't know you were in the Southern California desert, you would swear you were in the middle of Iraq")[4] give U.S. military recruits raised in the Midwest, the rural South, the northeastern rustbelt, or south central L.A. an equal opportunity not just to demonstrate their fire power with paintball "simunition" but to moderate their expletives (most Iraqis recognize the "f word"). Marine strategists now regard the inculcation of rudimentary manners "a force protection priority."

We modeled the controller [of the Dragon Runner, the new remotely controlled urban surveillance vehicle] after the Playstation 2 because that's what these eighteen- to nineteen-year-old Marines have been playing with pretty much all their lives.
— U.S. Major Greg Heines

Shambroom's focus is on those sites where disaster and specters of war hit much closer to home, though the imaginary of military preparedness is everywhere in evidence in his Security series, from the head-to-toe combat gear, automatic weapons, and single-file formation of the SWAT team descending on a bungalow in Terror Town, New Mexico (Plate 44), to the Explosive Ordnance Disposal bomb suit leaning on the disarmingly petlike metallic robot posed in a grove of matching birch trees in Duluth, Minnesota (Plate 41). For all the pathos, humor, and everyday heroism of the subjects of these photographs, the series bears witness to the degree to which American life has become militarized: the war brought home and literalized beyond the figurative mantra ("the war on drugs," "the war on terror") invoked by politicians to authorize the budget allocations for defense and law enforcement that make such high-tech hardware possible in the first place. When all is said and done, this stuff really *costs*. According to a report on Minnesota Public Radio on September 21, 2006, a training exercise in which fourteen airmen from the 775th Explosive Ordnance Disposal Division got to fire off forty thousand (paintball) rounds from an assortment of M-9 handguns and M4 and M16 machine guns at Disaster City® in Playas, New Mexico, in August 2006 prior to their military deployment to Southeast Asia cost taxpayers approximately $70,000.

It makes you realize how awful the world can be.
— Benjamin Davis, furniture store worker and volunteer firefighter, paid ten dollars an hour to act as a volunteer in disaster scenarios

Shambroom's large-format portraits of masked and protective-suited first responders have, to use his own words, "a bit of a superhero aura to them."[5] They stand before us larger than life as implausible, as awe-inspiring and Future World anachronistic as the caped crusaders in a midcentury DC or Marvel comic. Here, too, the ambiguity is rigorously sustained: the heroic self-erasure is also a bit menacing, even monstrous. Like Gregor Samsa caught midmetamorphosis there is something insectlike about them, a subhumanizing effect produced by the gas masks they all are wearing. To extend the ambiguity still further, the centered compositions, picturesque-to-the-point-of-pure-artifice backgrounds, and the mode of execution (digitally enhanced photographic images inkjetted onto stretched then varnished canvas) cite the visual conventions of eighteenth-century English portrait painting rather than the benday dot crudities of classic U.S. comic book art.

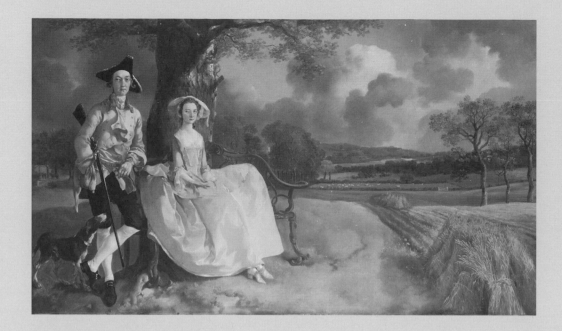

Thomas Gainsborough, <u>Mr. and Mrs. Andrews</u>, 1750.

6 John Berger, Ways of Seeing (London: British Broadcasting Company, 1972).

7 Cynthia Bowers, "Take a Trip to 'Terror Town' in Playas, New Mexico: All Hell Breaks Loose Every Day," CBS Evening News, Playas, New Mexico, February 13, 2006.

I guess these things are sort of half Gainsborough and half GI Joe.
— Paul Shambroom, "Picturing Security," Minnesota Public Radio, September 21, 2006

Framed squarely more or less dead center against the pastoral backdrop, the operative in the yellow Hazmat A suit (Plate 39) confers a glance on the viewer as direct, as proprietary, yet (thanks to the breathing gear's rubber beak and the reflective surface of the face mask) as aloof and unavailable for empathy as the down-their-noses look Mr. and Mrs. Andrews gave Thomas Gainsborough (and through him, us) in the famous portrait of the newly married couple begun in late 1748 and early 1749. Back then and there (eighteenth-century southern England), as (Marxist) art critic John Berger pointed out in Ways of Seeing, the landscape functions first and foremost as property.[6] The two aristocrats are placed by Gainsborough in leisurely poses in the foreground. Robert lounges with his gun and dog while Frances is arrayed in blue satin on a rococo bench. Both appear indifferent to the viewer because in their eyes in this context only they matter (the portrait, after all, was made for them). They and they alone own all the eye can see. Mr. Andrews's huge estate (cannily enlarged through his wife's dowry) stretches off into the distance past orderly wind breaks and hedge-rows to the low Sussex hills on the horizon.

The placement and the pose of the figure in Shambroom's portrait imply the same principle and order of possession. Proprietorship has been translated into terms commensurate with America's status as New World demonstration project: meritocratic-egalitarian yet corporate capitalist, terrorist target and solitary global superpower. Anonymous, ungendered, indigenous, and democratic, the Suit (as elsewhere in the Security series, the wearer isn't named) bears the insignia of office appropriate to that status. Instead of Mr. Andrews's musket (after all, this isn't 1776), toxic material detection apparatus is suspended from the left shoulder. A Geiger counter rests in the right-gloved hand. In the left its probe is held across the heart like an antique scroll, some sacred foundational document in a patriotic history painting from the Revolutionary period — Benjamin

Franklin, perhaps, bringing the Declaration of Independence to be signed (after all, deep down, it's always 1776). This landscape, beautiful but toxic (toxic by association, its paradisiacal appearance undercut by the presence of its yellow visitor), is Hazmat A suit's patrimony. This is Hazmat A suit's Eden-after-the-Fall, always-already pristine yet poisoned. Romantically rendered, digitally manipulated, this is Our Homeland (about-to-be-just-about) Secured.

The tension between the protective space suit and the David Lynch–like picture-perfect setting, between the Suit's chemically resistant acid primaries and the soft greens and browns of the surrounding earth and vegetation, becomes insupportable at the point where the yellow-soled red rubber boots touch terra firma. The figure appears superimposed. It seems to float in virtual space like an avatar in a kill-or-be-killed video game. Like some science fiction apiarist in a world without bees, the Suit stands as the custodian of a decimated resource, a resource depleted to the point of extinction.

No harmonious or sustainable relationship between the human and natural realms is implied here or elsewhere in Shambroom's Security series. This is a long way from Mr. and Mrs. Andrews in their finery lording it over a well-groomed estate: high culture over horticulture. This is Us against Them, Us-as-It against It-in-Us/It-outside-Us. This is Buzz Aldrin on a bad day on the moon. Or, to be more literal and geographical about it, as Shambroom's caption notes, this is Yellow Hazmat A Suit in Disaster City®, National Emergency Response and Rescue Training Center, at Texas Engineering and Extension Service in College Station, Texas, a place not unlike the emerging twenty-first-century American Dreamscape, where, to quote the TEEX web site, "tragedy and training meet and where anything is possible."

Terror Town, in Playas, New Mexico, a place "where all hell breaks loose . . . all the time,"[7] is managed by New Mexico Tech and is Disaster City's sister facility; it also features prominently in Security (Plates 40, 44, and 46). Situated in the arid boot heel of southwestern New Mexico and developed in the 1970s as a company town by the copper-mining Phelps Dodge Corporation, Playas in its heyday was home

to a population of around one thousand, the majority of whom found employment at the copper smelter located ten miles south of town. After the collapse of the U.S. copper market in 1999, Phelps pulled out and all but a handful of the residents were evicted or moved. In 2003 New Mexico Institute of Mining and Technology bought the entire town and the surrounding twelve hundred acres for five million dollars, using funds from the Department of Homeland Security. New Mexico Tech receives an annual grant of twenty million dollars from Homeland Security to administer Terror Town as a training and research facility for first responders and counterterrorism programs and as housing for national guard troops deployed to aid the border patrol in border security. Back in the day before Playas died and was born again as Terror Town, the Playas smelter was nicknamed *la estrella del norte* by the illegal immigrants who would use its lights as a navigational marker when crossing into the country from the Mexican border, about forty miles south.

Yodaville, Arizona, a simulated global south city made from twenty-three thousand cluster bomb containers and with a mock soccer field painted green on the edge of town, is only seven miles from the same border. The U.S. military's first urban bombing training site, the Yoda complex opened in 1998. According to Stephen Graham, "bombing runs are stopped at least twice weekly so that immigrants, newly arrived across the border, can be removed from the site, before the ordnance once again rains in."[8]

Meanwhile, in a parallel universe, Dennis Steele, a military reporter writing in Army maga-zine, describes the new cordon and checkpoint system installed around Taramiyah in Iraq as "the Iraqi version of a gated community — no luxury estates, no backyard pools, no country club, but the purposes are the same: keep out the bad elements."[9]

For Paul Shambroom, the ambiguities and contradictions of the homeland security and emergency simulation industries — our endless rehearsals of multiform catastrophe, our collective preparations-to-perfection for the worst —are encoded, both secreted and exposed, in the paradoxical light that plays across his prints, hyperrealizing his subjects

while simultaneously undercutting the veracity of each scene. According to the artist, he became intrigued with the use of baffling light after studying traditional portrait painting:

They'd take a sitter into the studio and do the portrait portion with indirect beautiful soft northern light from skylights and windows; then they would take that portrait and drop it into a landscape that sometimes was painted by their assistants. There's a kind of incon-sistency in the lights when you study these paintings . . . There's just something a little weird about them. My hope is that when you look at them they seem oddly familiar.[10]

——

Dick Hebdige is professor of art and film studies and director of the Interdisciplinary Humanities Center at the University of California, Santa Barbara. A cultural critic and theorist, he has published widely on youth subculture; contemporary music, art, and design; and consumer and media culture. Among his books are Subculture: The Meaning of Style and Cut 'n' Mix: Culture, Identity, and Caribbean Music. His interests include the integration of autobiography and mixed media in critical writing and pedagogy.

8 Graham, "Theme Park Archipelago," 9.

9 Dennis Steele, Army (September 2006): 1.

10 Jay DeFoore, "Paul Shambroom Explores Homeland 'Security,'" podcast, September 2006. www.popphoto.com/ americanphotopodcasts.

1 Boeing Company, Everett, Washington (747 aircraft), 1987

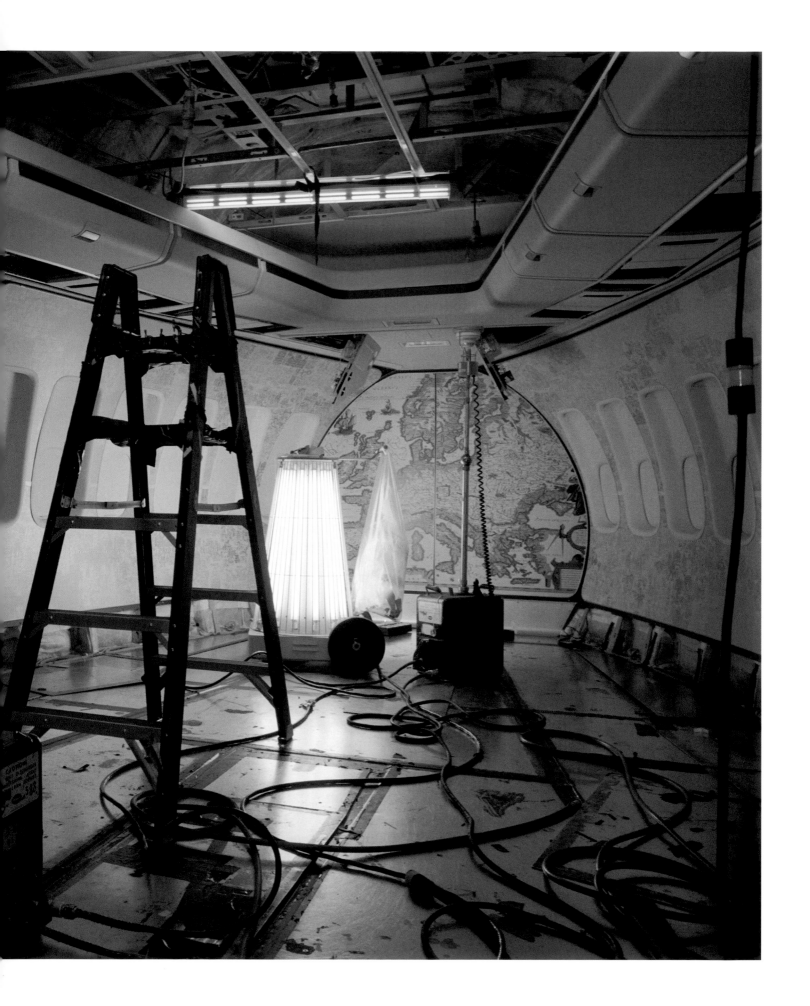

2 Hughes Aircraft Company, El Segundo, California (Intelsat VI satellite), 1988

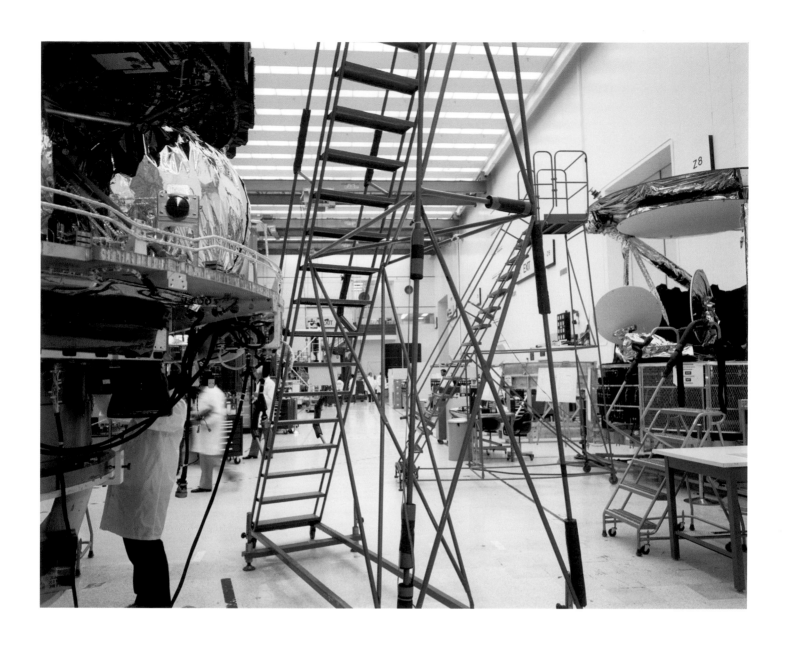

3 Valspar Corporation, Minneapolis, Minnesota (paint), 1987
4 Honeywell, Inc., Golden Valley, Minnesota (residential controls), 1986

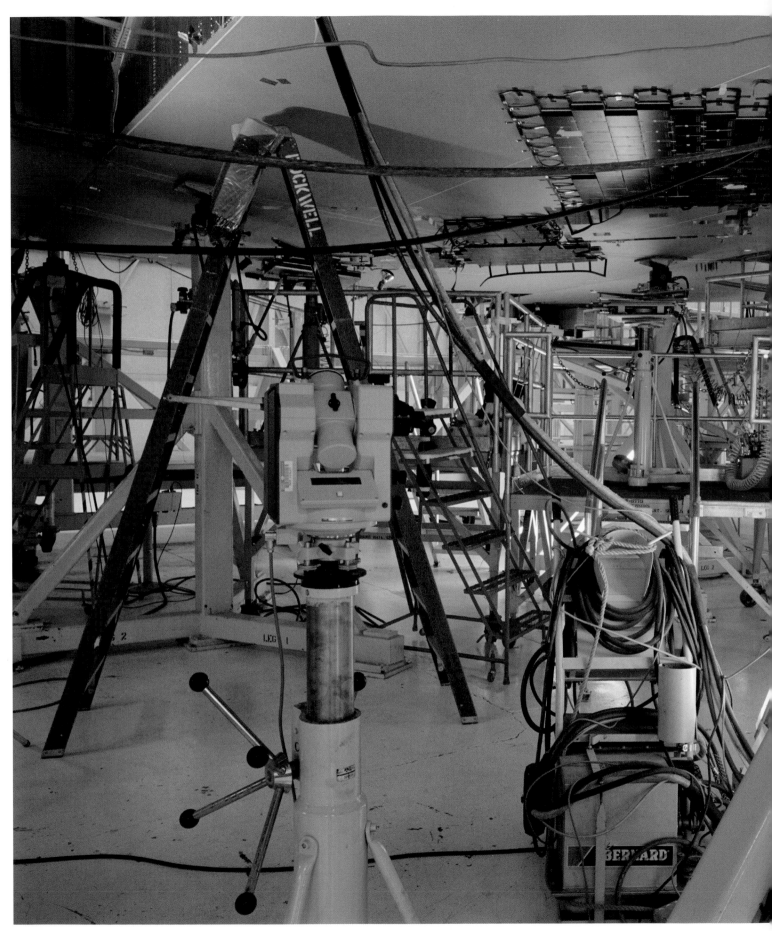

5 <u>Rockwell International, Palmdale, California (space shuttle orbiter Endeavor)</u>, 1988

6 North Star Steel Company, St. Paul, Minnesota, 1988

7 <u>Badger Foundry Company, Winona, Minnesota (ferrous metal foundry)</u>, 1986

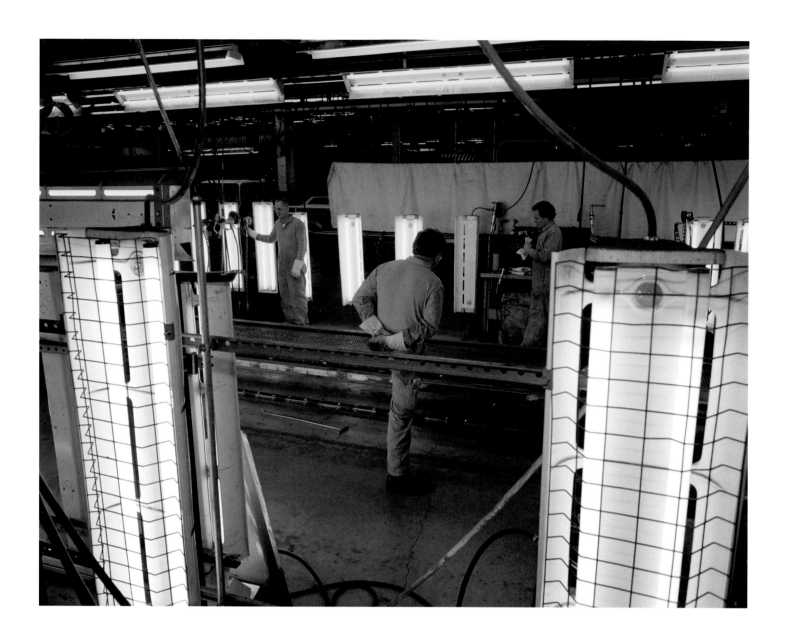

8 Ford Motor Company, St. Paul, Minnesota (truck assembly), 1986
9 Mentor Corporation, Minneapolis, Minnesota (penile implants), 1988

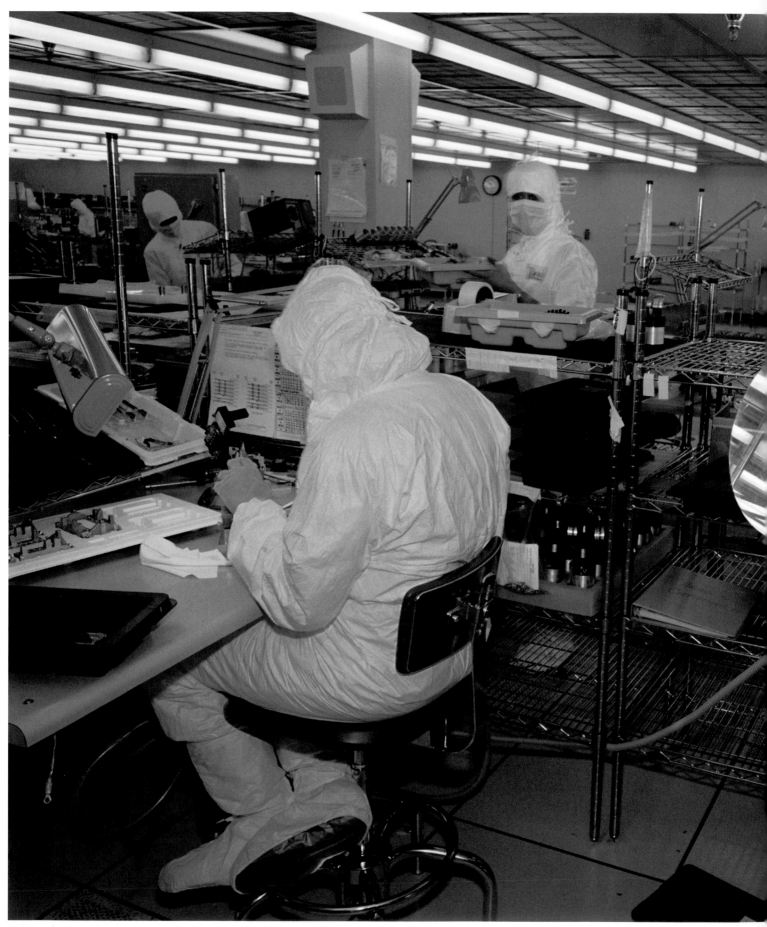

10 <u>Control Data Corporation, Bloomington, Minnesota (computer disk drives)</u>, 1986

11 <u>First Bank System, Inc. (#1), Minneapolis, Minnesota</u>, 1989

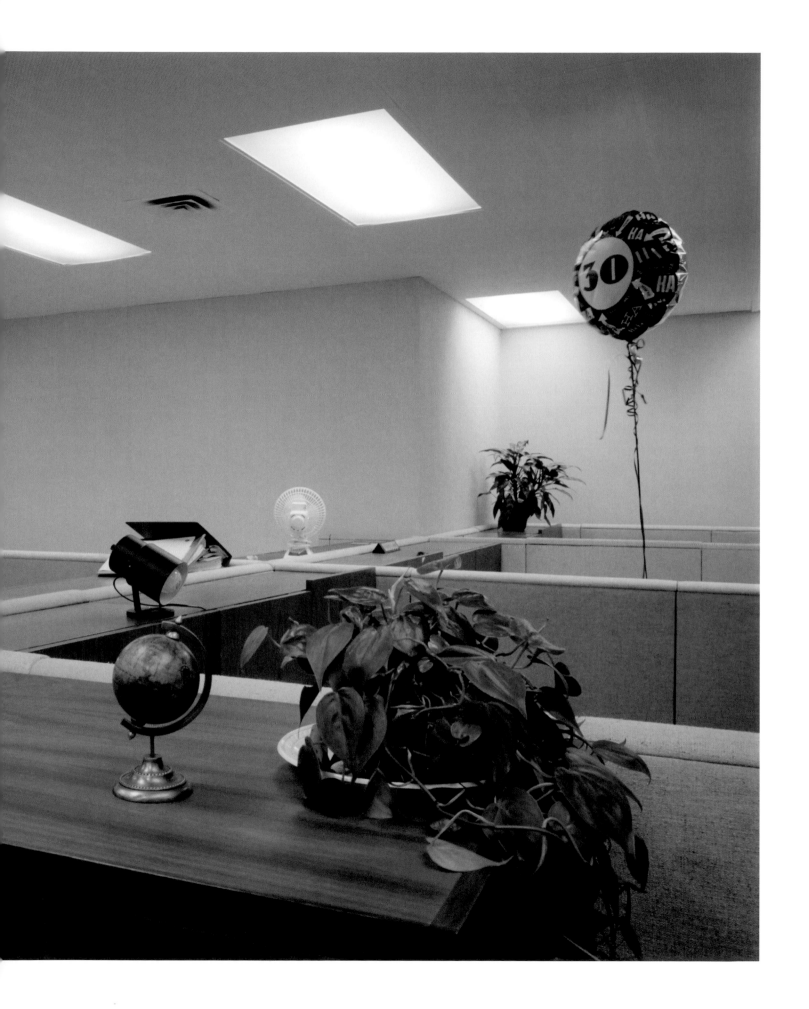

12 <u>First Bank System, Inc. (#2), Minneapolis, Minnesota</u>, 1989

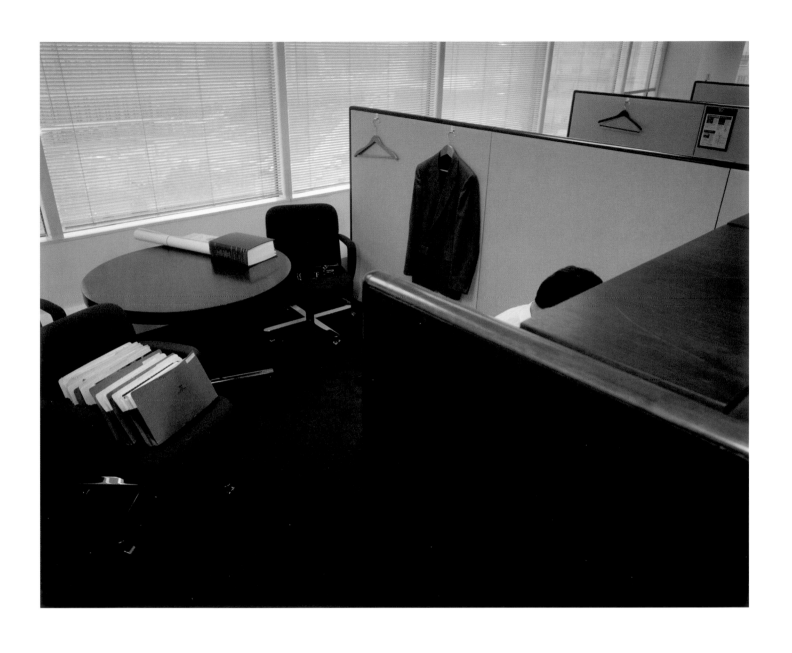

13 <u>General Mills, Inc. (#4), Golden Valley, Minnesota</u>, 1989

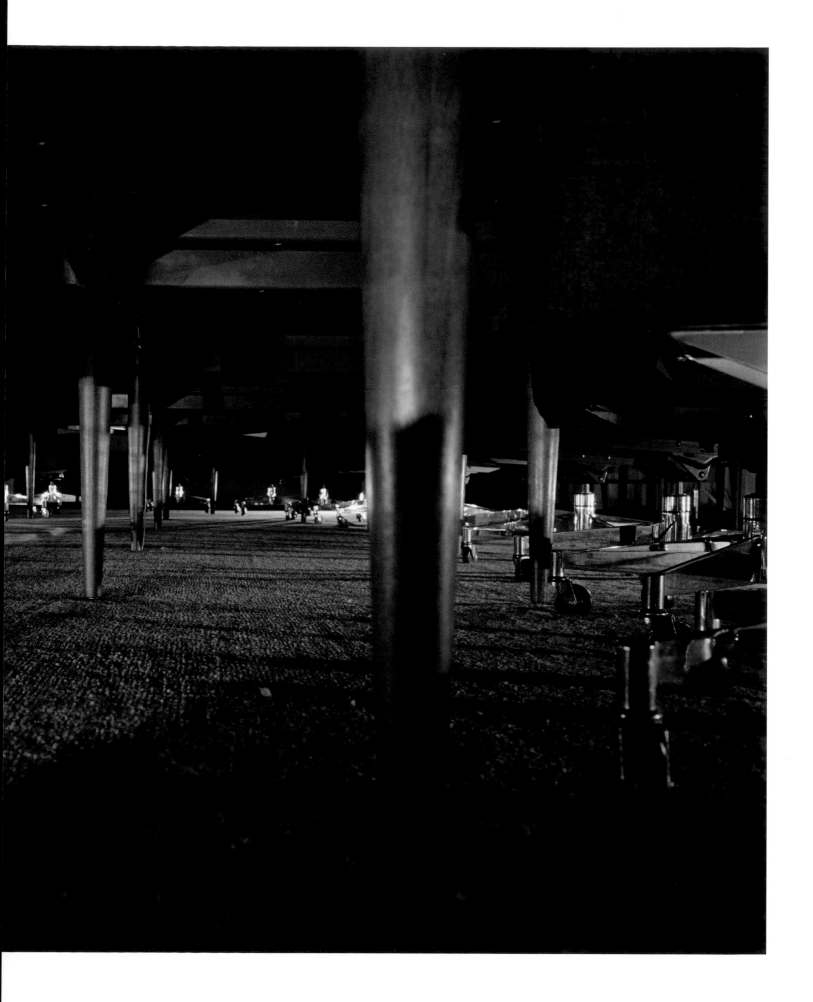

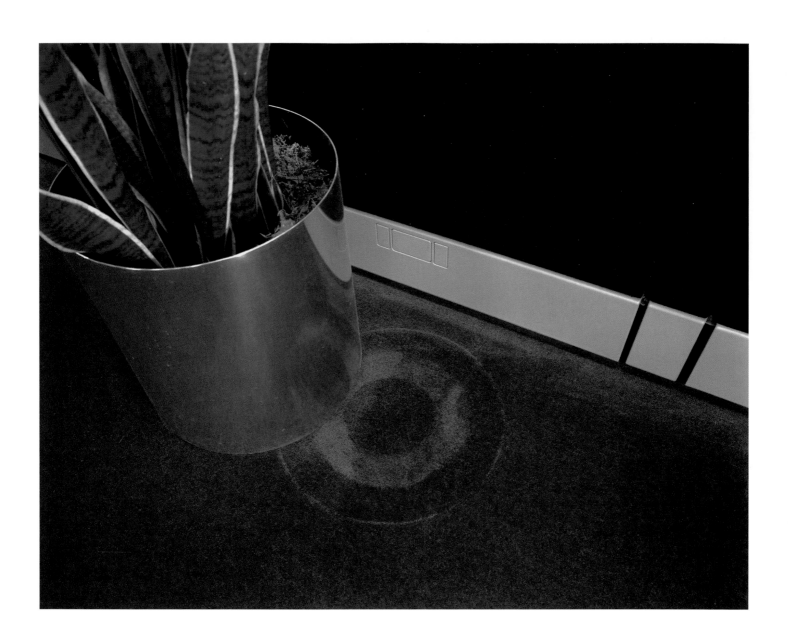

14 <u>Cray Research, Inc. (#3), Minneapolis, Minnesota</u>, 1989
15 <u>General Mills, Inc. (#1), Golden Valley, Minnesota</u>, 1989

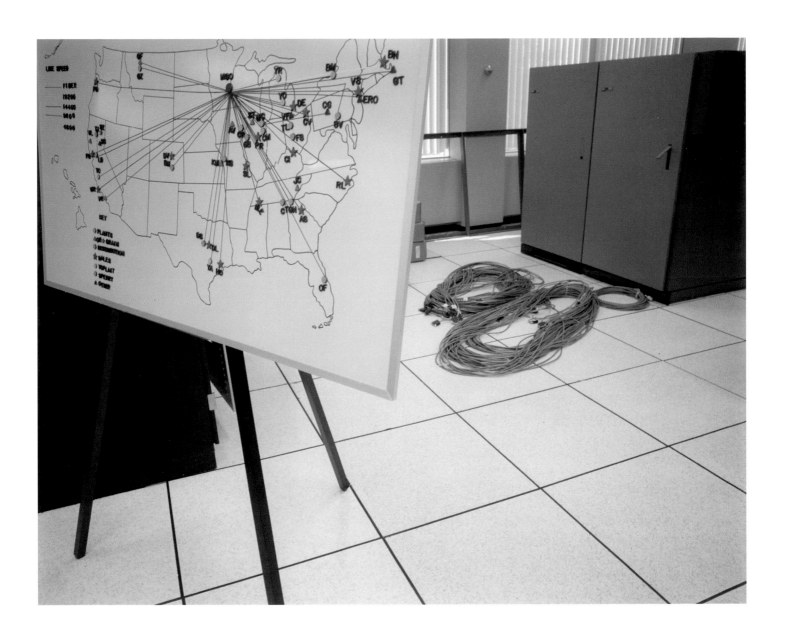

16 <u>Honeywell, Inc. (#1), Minneapolis, Minnesota</u>, 1989

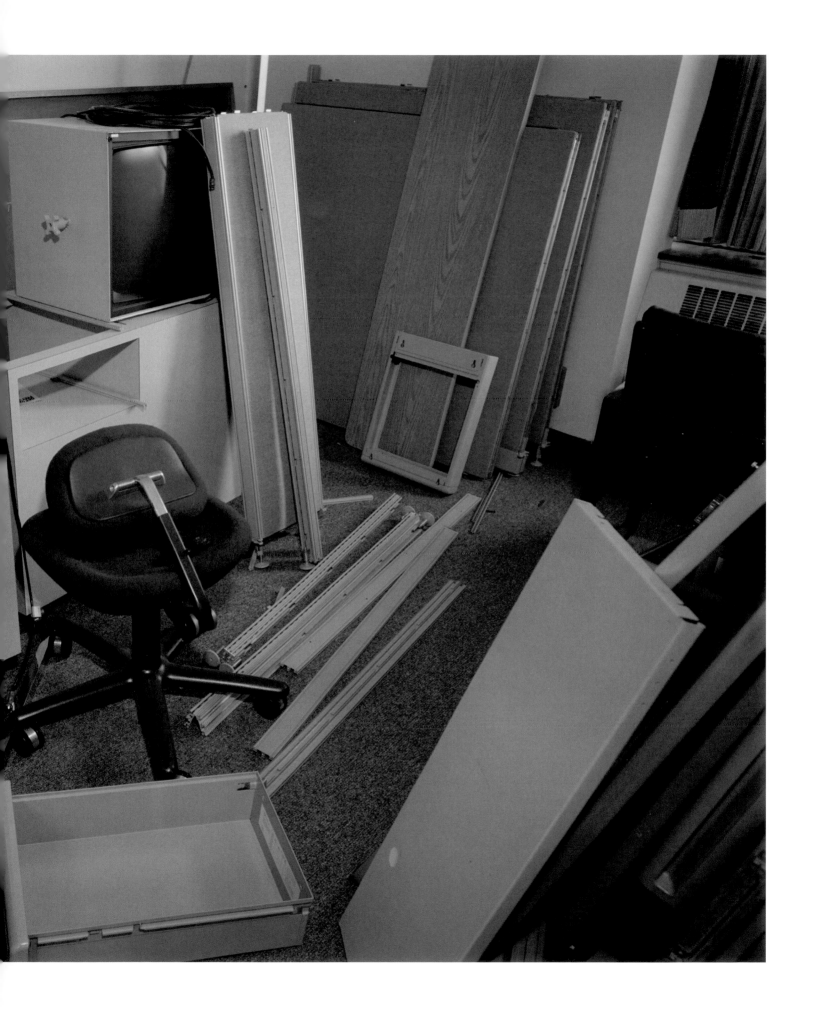

17 <u>General Mills, Inc. (#5), Golden Valley, Minnesota</u>, 1989

18 B83 one-megaton nuclear gravity bombs in Weapons Storage Area,
Barksdale Air Force Base, Louisiana, 1995

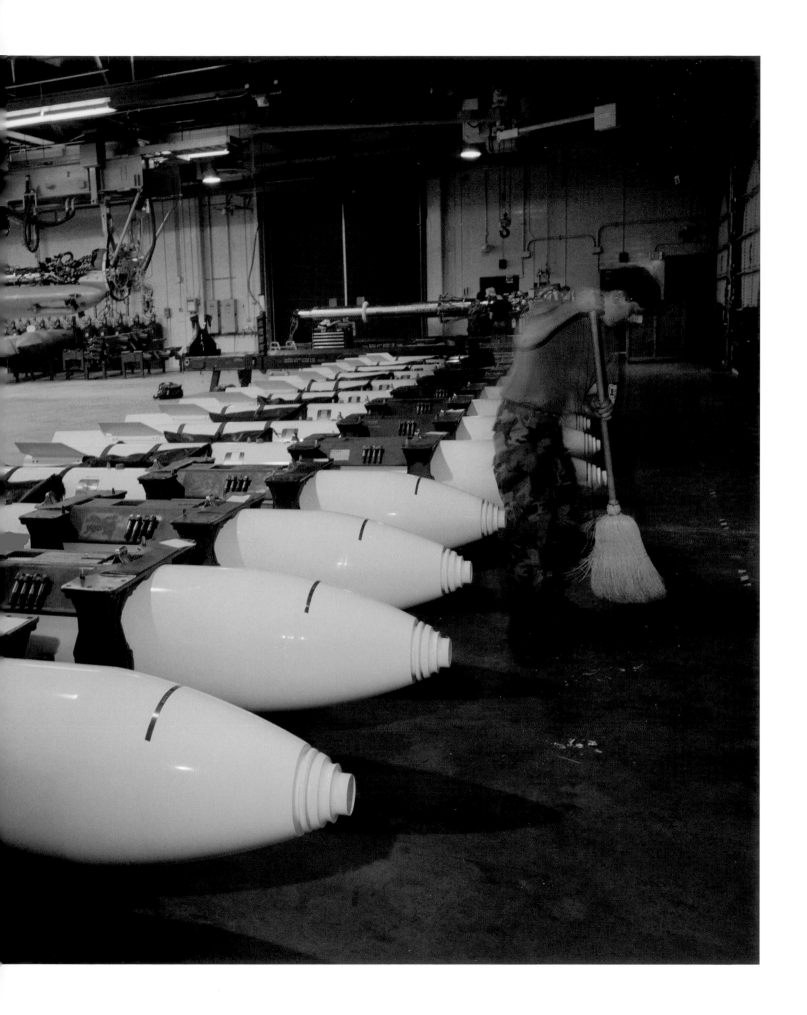

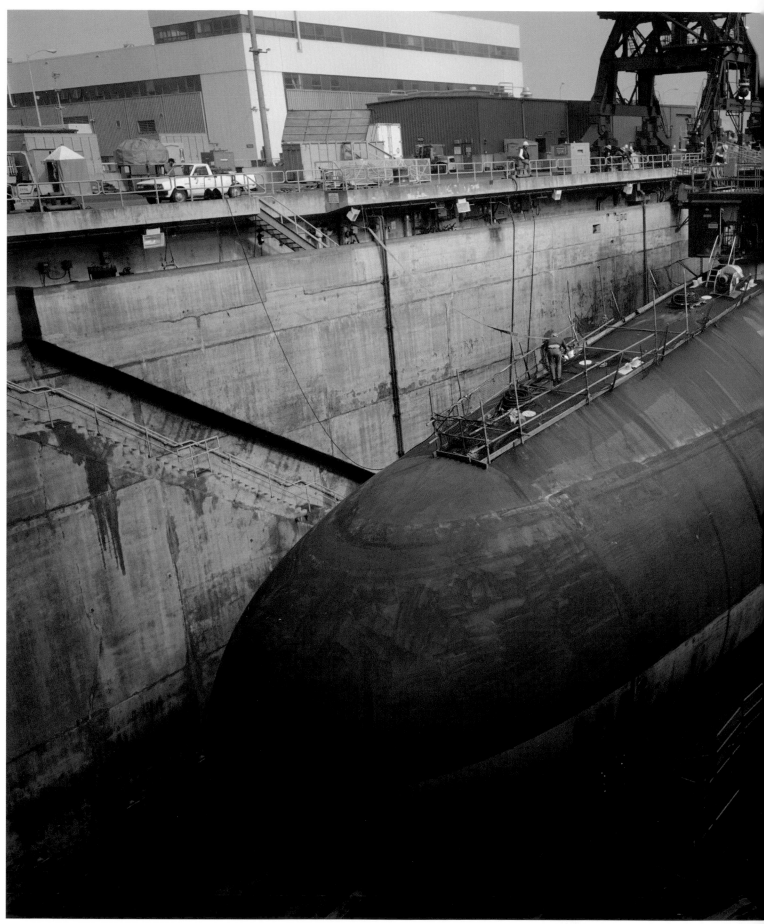

19 <u>Ohio class Trident submarine USS Alaska in dry dock for refit</u>, <u>Naval Submarine Base Bangor, Washington</u>, 1992

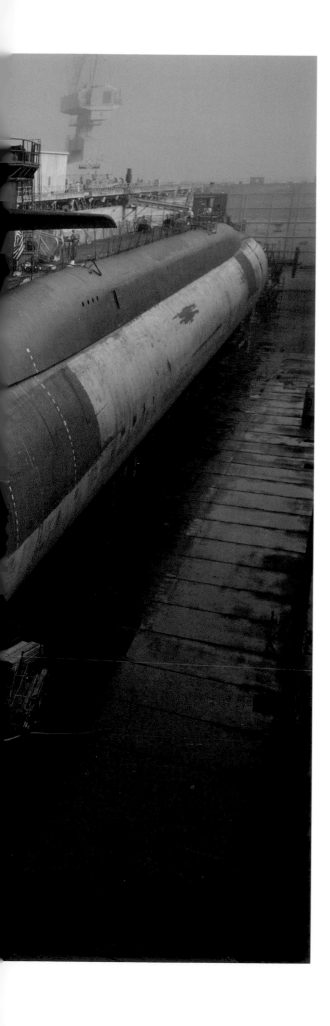

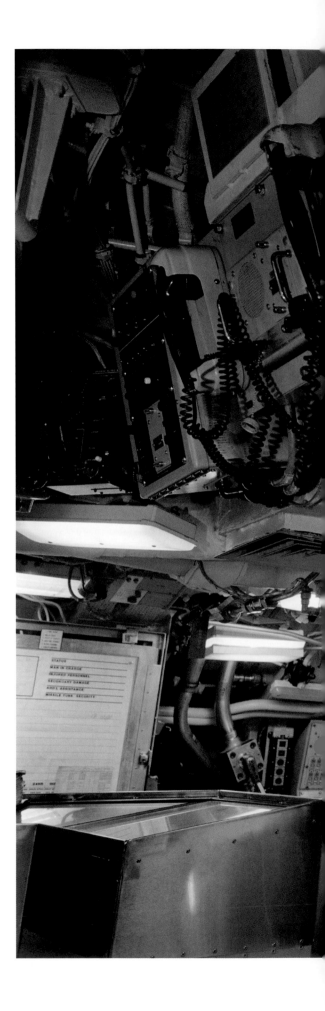

20 <u>Trident submarine control room, USS Alaska, Naval Submarine Base Bangor, Washington</u>, 1992

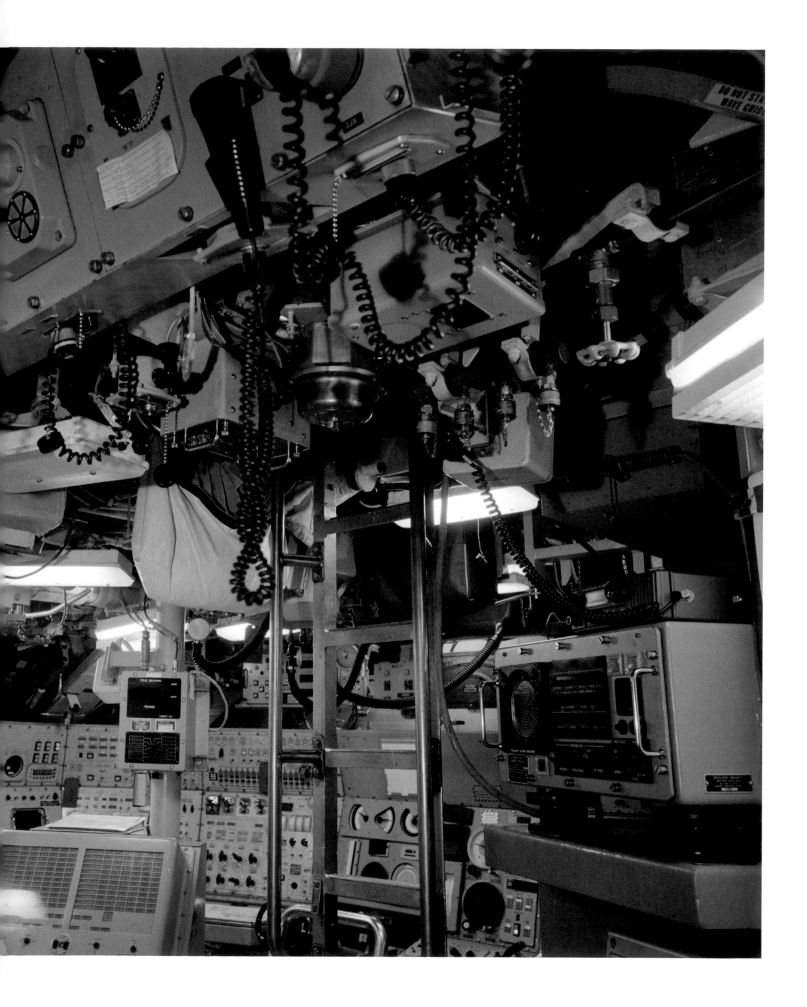

21 <u>Poseidon submarine missile hatches, USS Stonewall Jackson, Naval Submarine Base Kings Bay, Georgia</u>, 1994

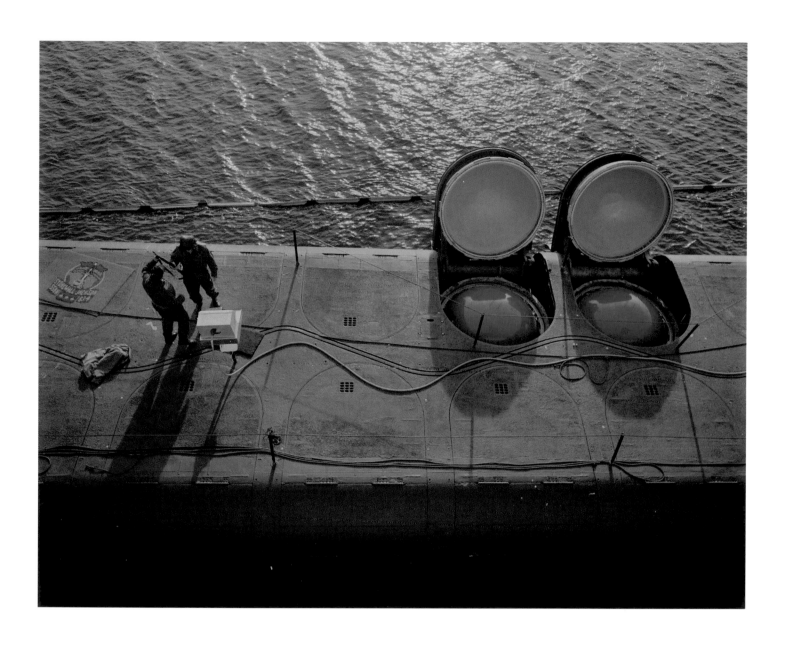

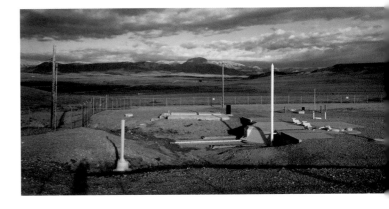

22 <u>Nine ICBM silos</u>, 1992 – 2001. Left to right, top to bottom: <u>Minuteman III "Alpha 7," Egbert, Wyoming</u>; <u>Minuteman III "Kilo 5," Dix, Nebraska</u>; <u>Minuteman II "Foxtrot 9," Leesville, Missouri</u>; <u>Minuteman III "India 8," Ross, North Dakota</u>; <u>Minuteman III "Mike 6," Merino, Colorado</u>; <u>Minuteman II "Lima 6," Vale, South Dakota</u>; <u>Minuteman III "Foxtrot 10," Coteau, Montana</u>; <u>Minuteman III "Juliet 8," Peetz, Colorado</u>; <u>Minuteman III "Golf 7," Bowman's Corners, Montana</u>.

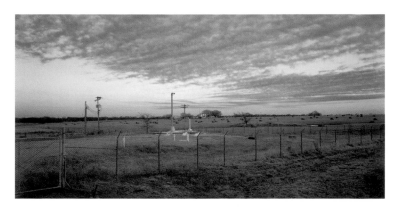

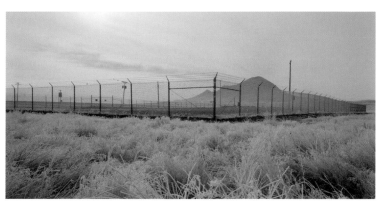

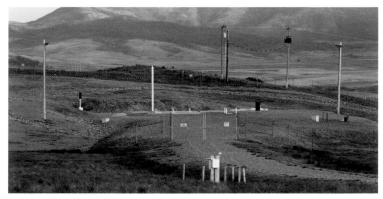

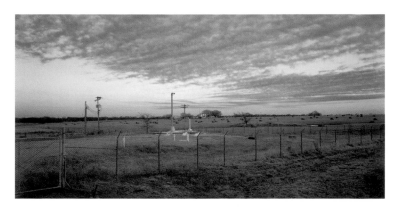

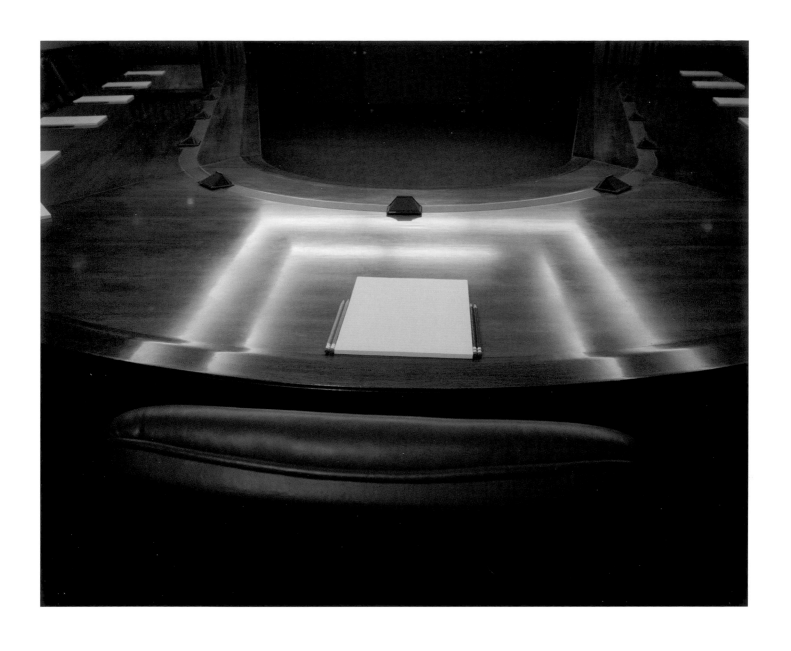

24 <u>Combat Alert Facility for bomber crews, Ellsworth Air Force Base, South Dakota</u>, 1992

25 Blast door, "November 1" Minuteman II Launch Control Center, Newell, South Dakota, 1992

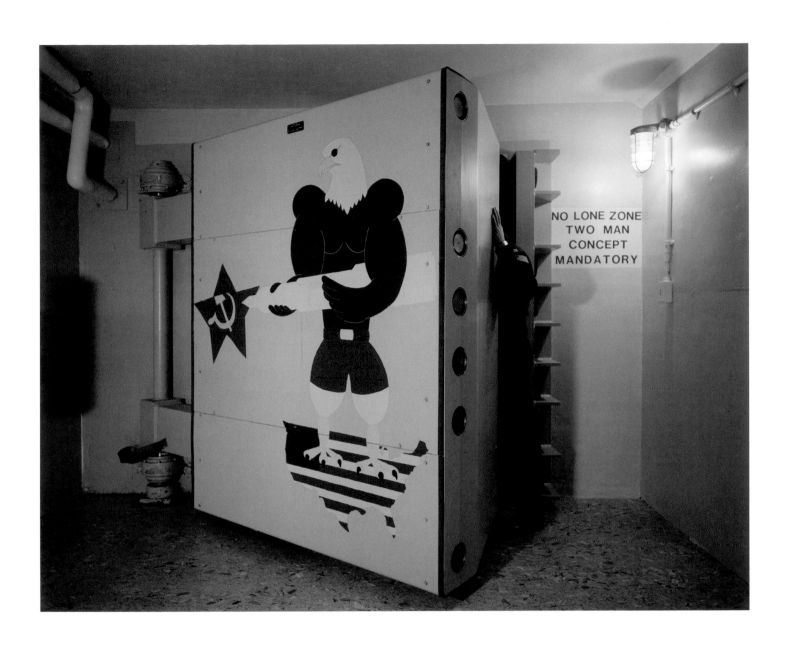

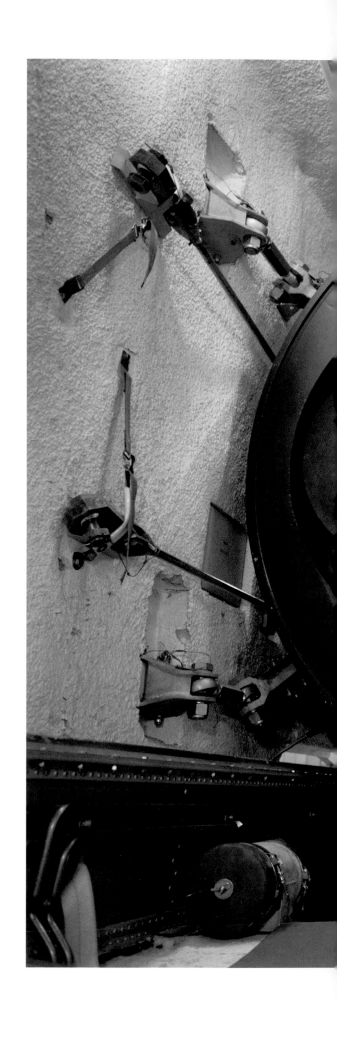

26 Minuteman II Missile in Transporter Erector Vehicle,
Ellsworth Air Force Base, South Dakota, 1992

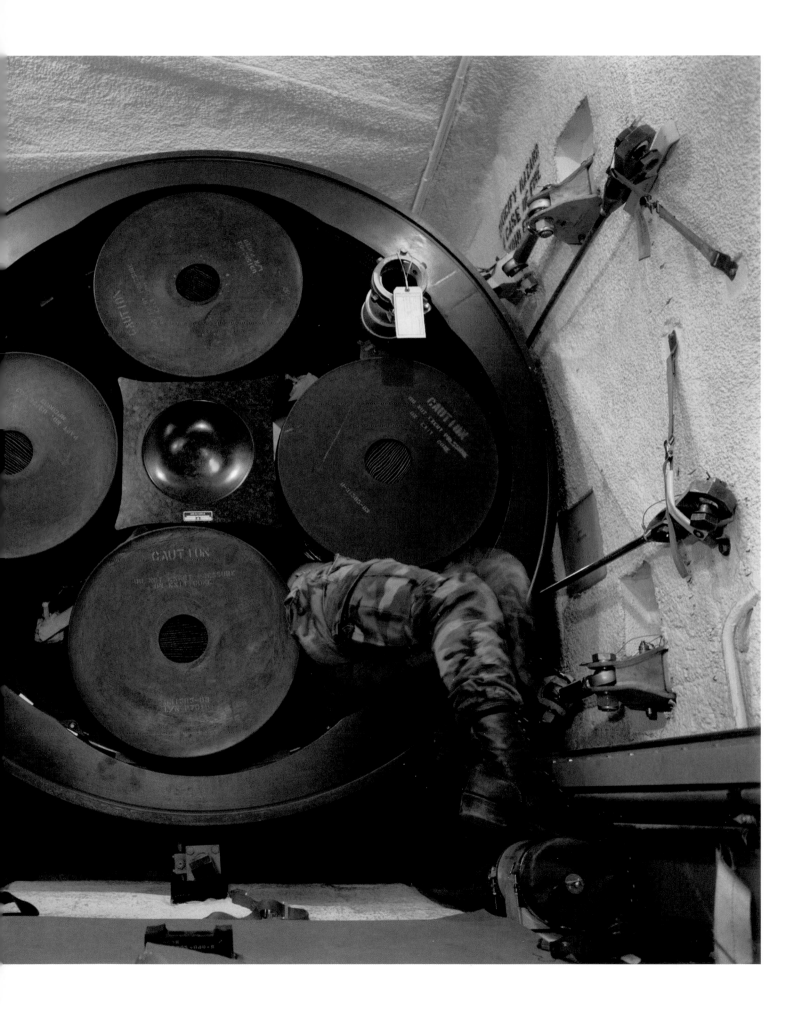

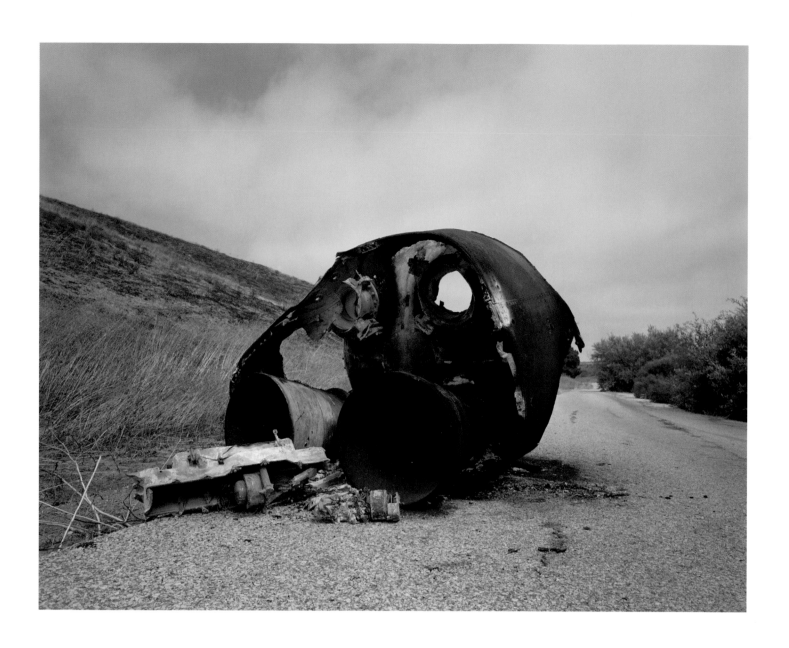

27 <u>Debris from first stage of unsuccessful Minuteman I missile test launch, Vandenberg Air Force Base, California</u>, 1993
28 <u>Peacekeeper missile test launch preparation, Vandenberg Air Force Base, California</u>, 1993

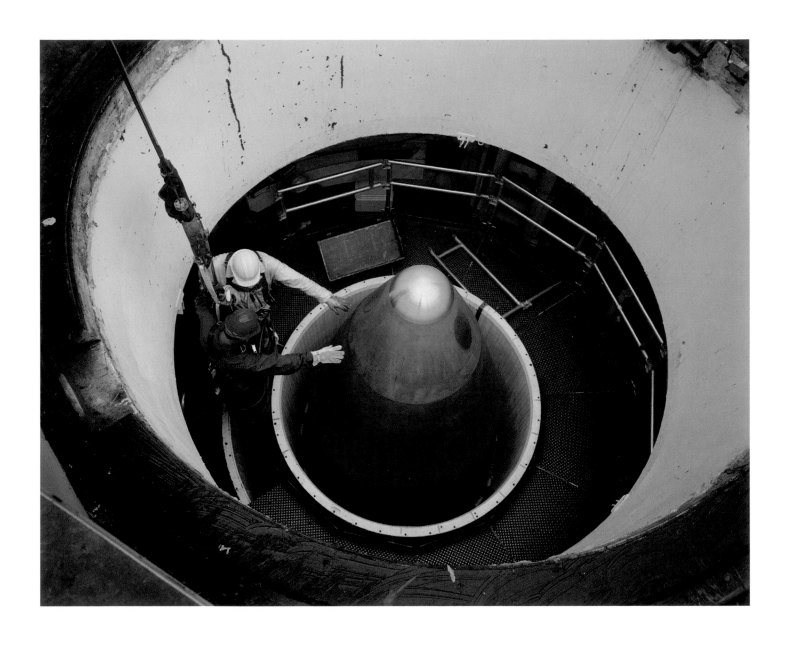

29 Peacekeeper missile W87/Mk-21 Reentry Vehicles (warheads) in storage,
F. E. Warren Air Force Base, Cheyenne, Wyoming, 1992

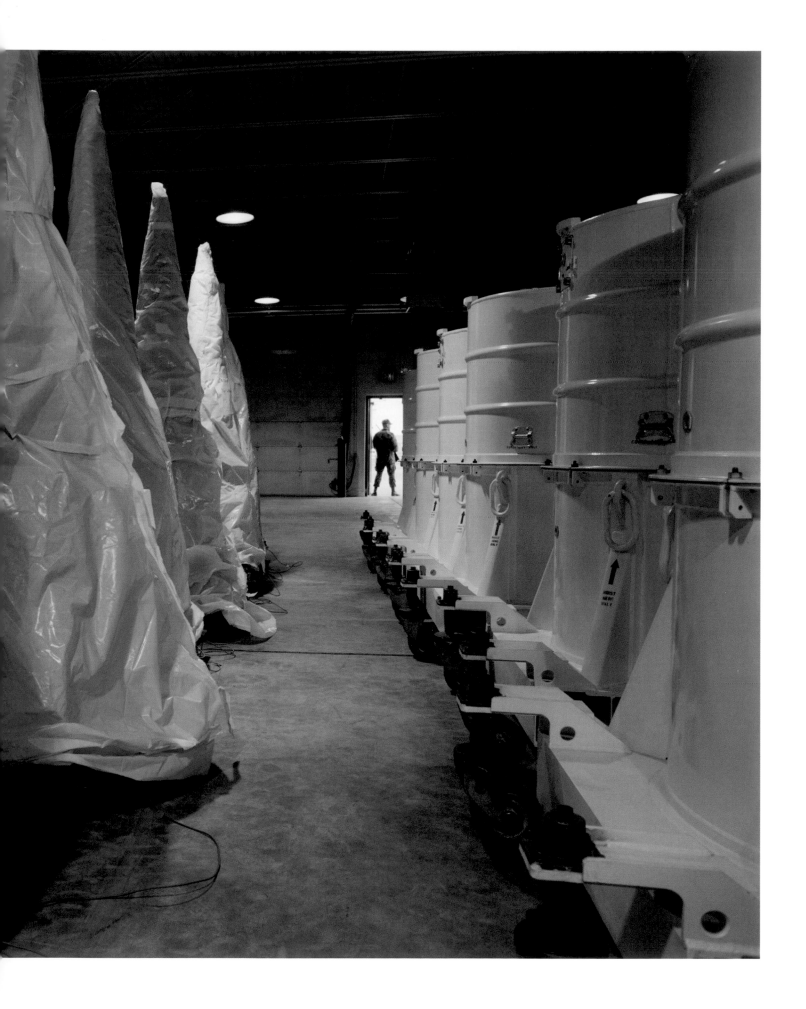

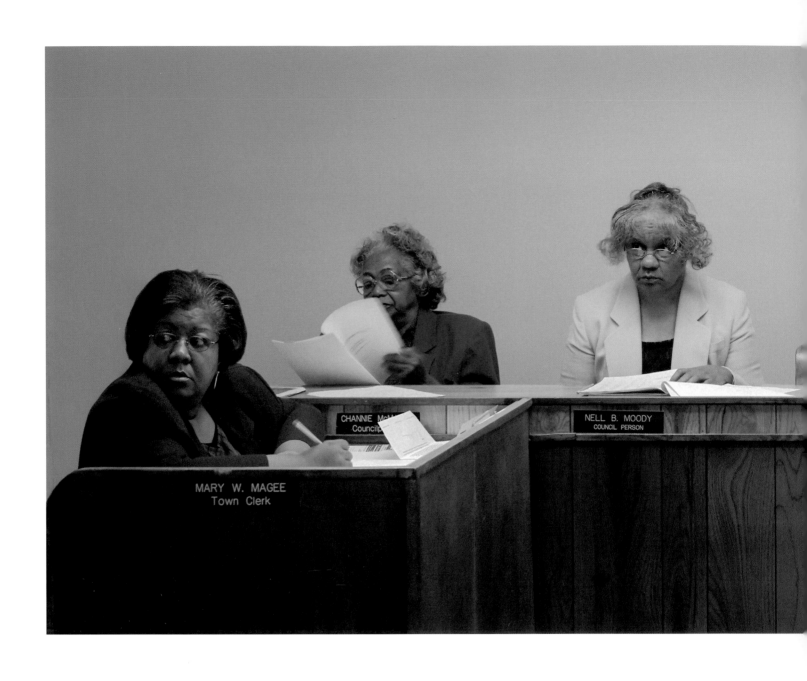

30 <u>Dobbins Heights, North Carolina (population 936) Town Council, November 8, 2001</u>, 2001. Left to right: Mary Magee (clerk), Channie McManus, Nell Moody, Christine Davis, Gracie Jackson (mayor pro tem).

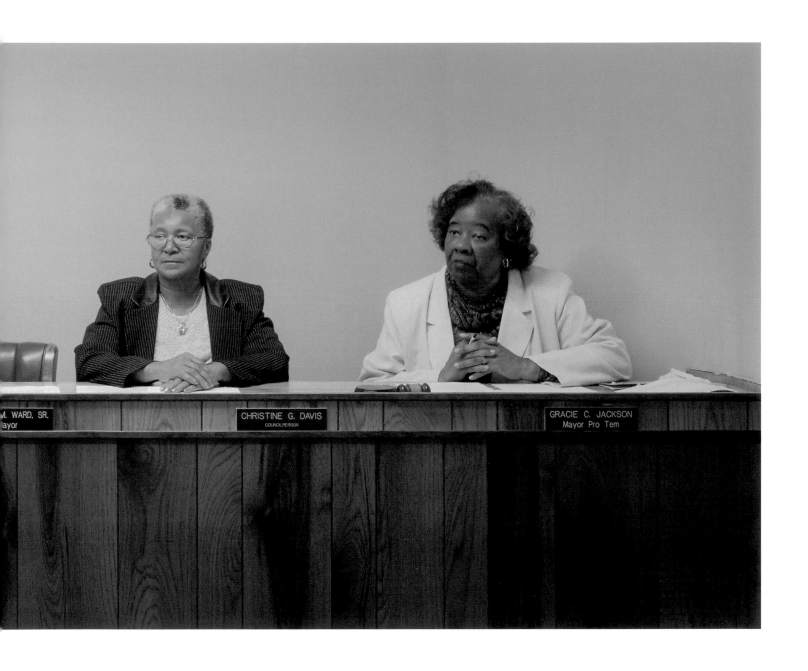

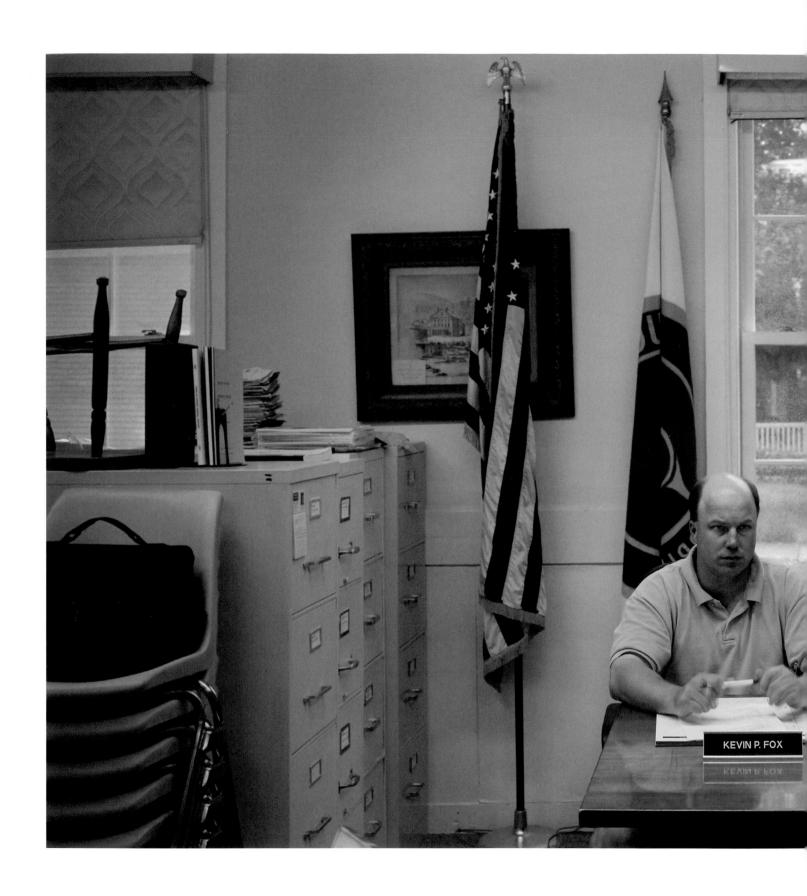

31 <u>Buckland, Massachusetts (population 1,943) Board of Selectmen, July 27, 1999</u>, 1999. Left to right: Kevin P. Fox, John F. Brosnan (chair).

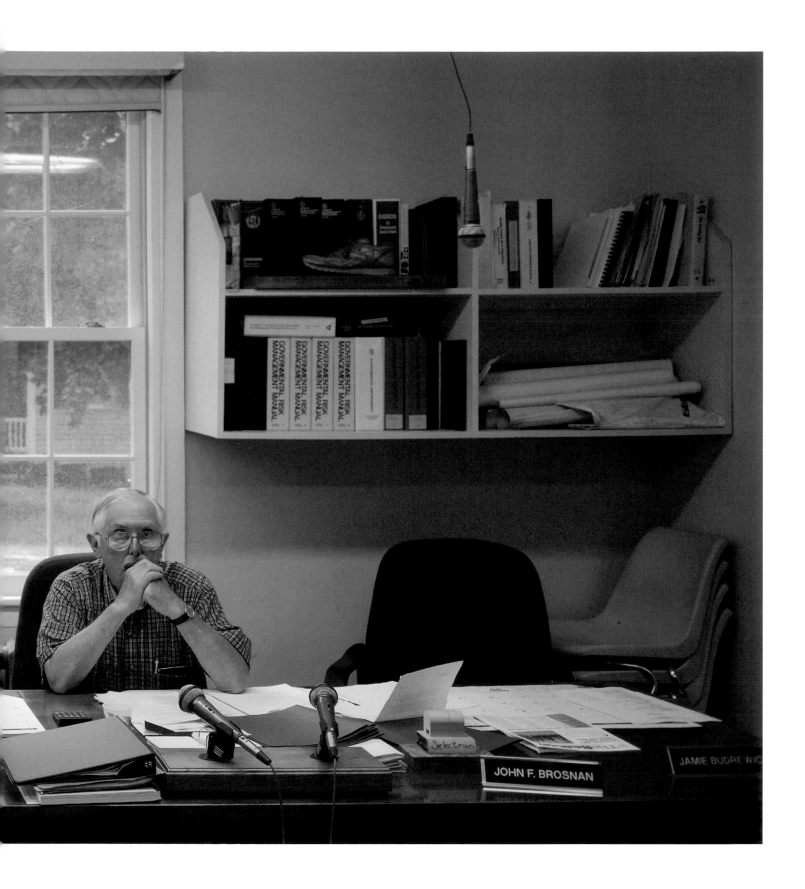

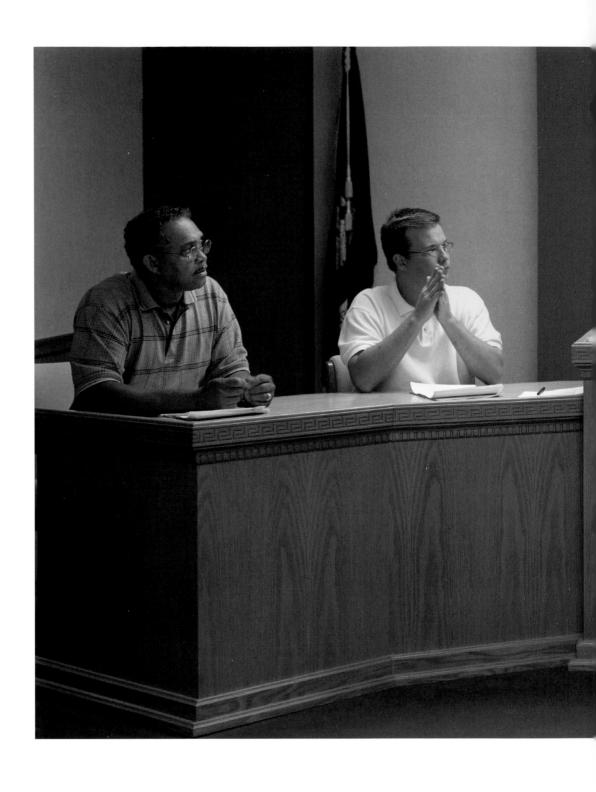

32 <u>Maurice, Louisiana (population 642) Village Council, May 15, 2002</u>, 2002. Left to right: Paul Catalon, Lee Wood, Barbara Picard (mayor), Mary Hebert (clerk), Marlene Theriot.

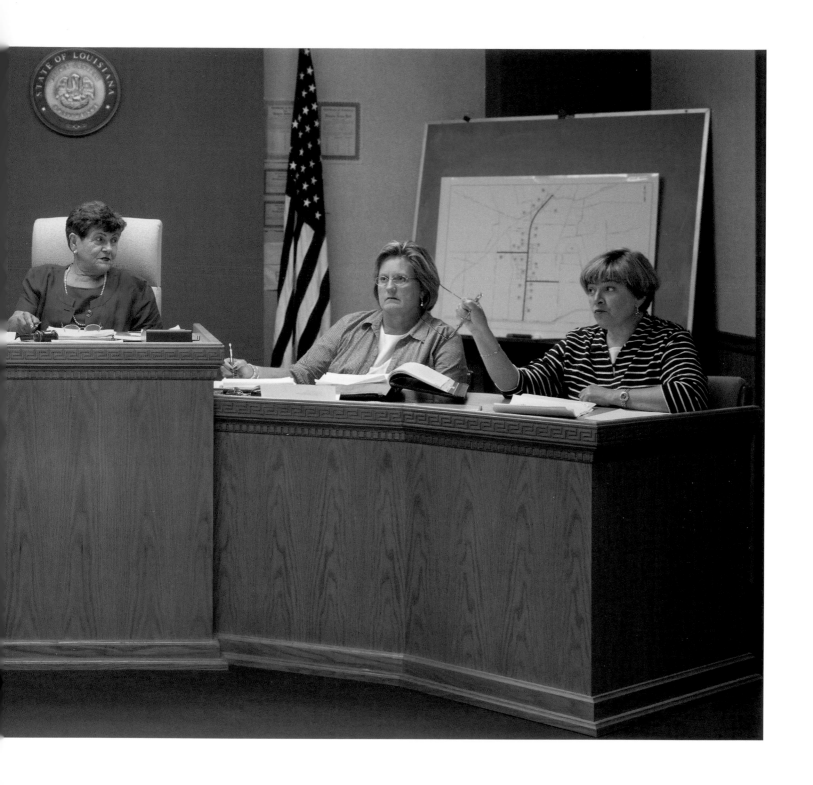

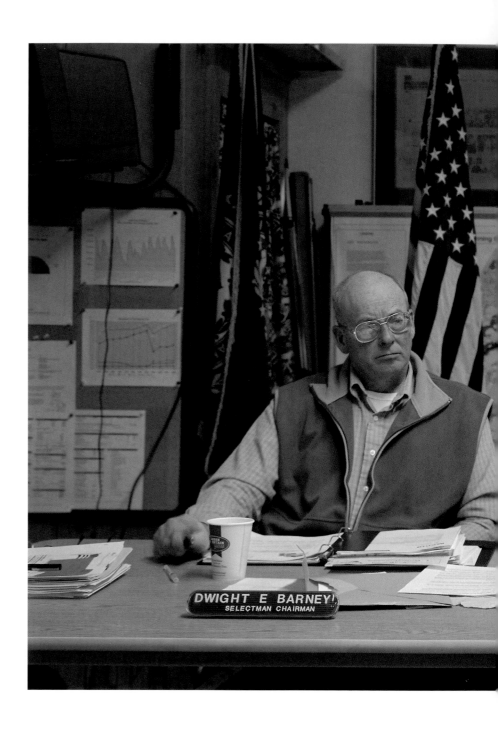

33 <u>Lee, New Hampshire (population 4,145) Board of Selectmen, January 27, 2003</u>, 2003. Left to right: Dwight Barney (chairman), Joseph Ford, Richard Wellington.

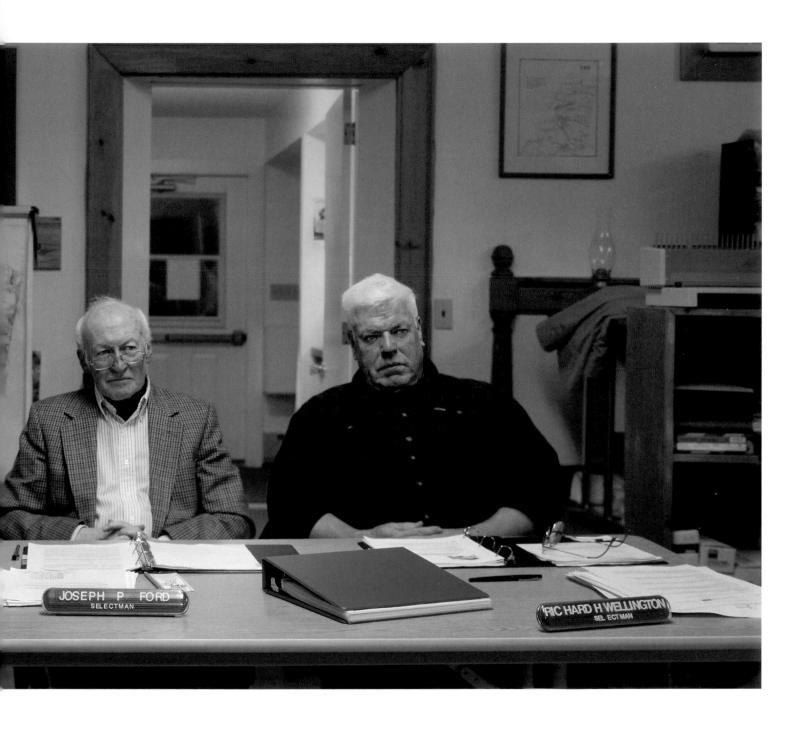

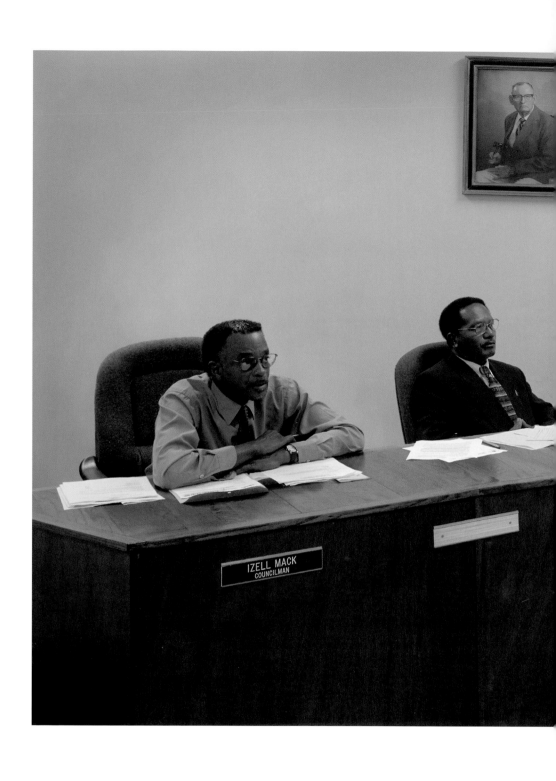

34 <u>Wadley, Georgia (population 2,468) City Council, August 13, 2001</u>, 2001. Left to right: Izell Mack, Charles Lewis, Albert Samples (mayor), Robert Reeves (city attorney).

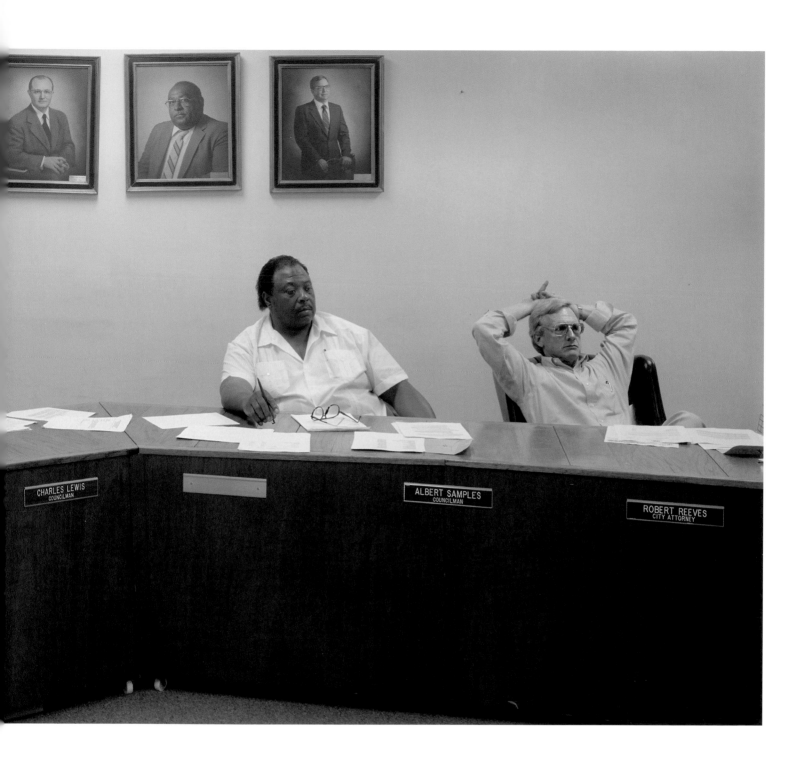

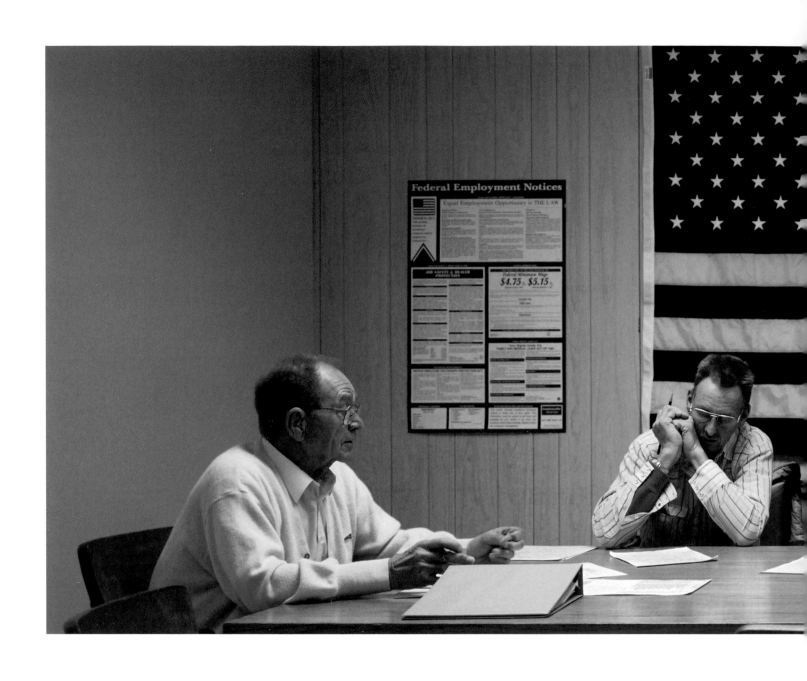

35 <u>Lewiston, Minnesota (population 1,405) City Council, March 10, 1999</u>, 1999. Left to right: Roger Laufenburger (mayor), Denny Engrav, Gary Sauers, Robert Rys (city administrator).

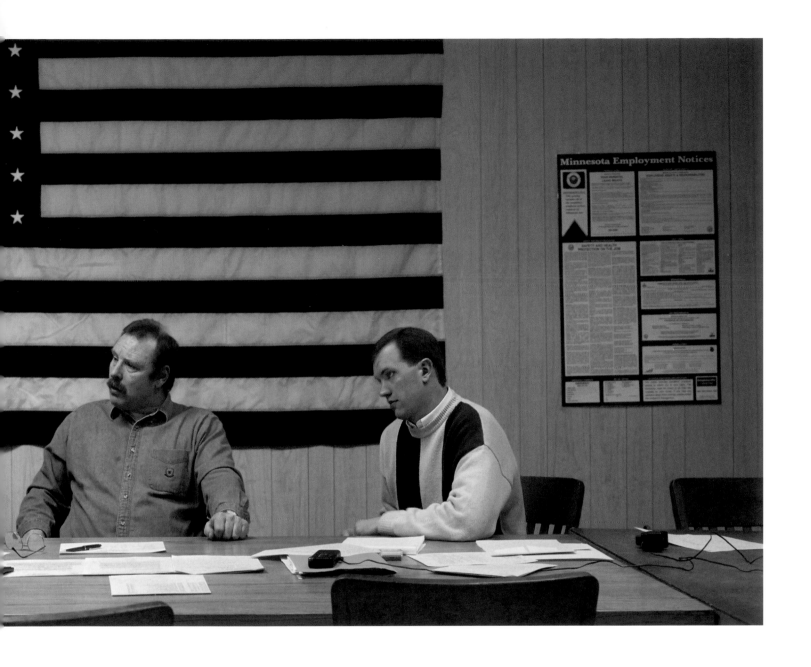

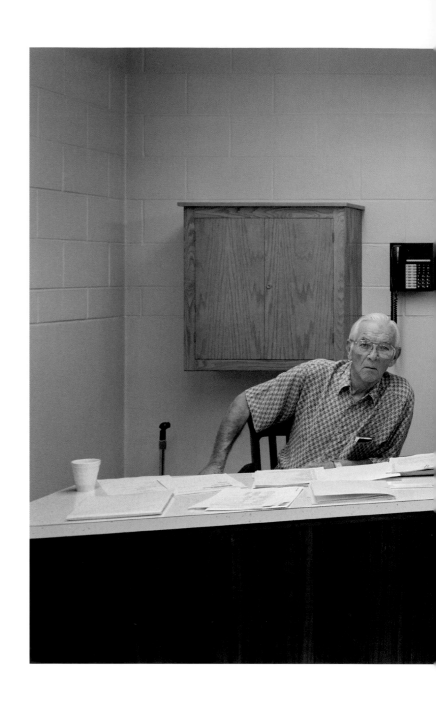

36 <u>Markle, Indiana (population 1,228) Town Council, July 21, 1999</u>, 1999. Left to right: Wayne Ridgley, Jay Fox (president), Jeff Stockman.

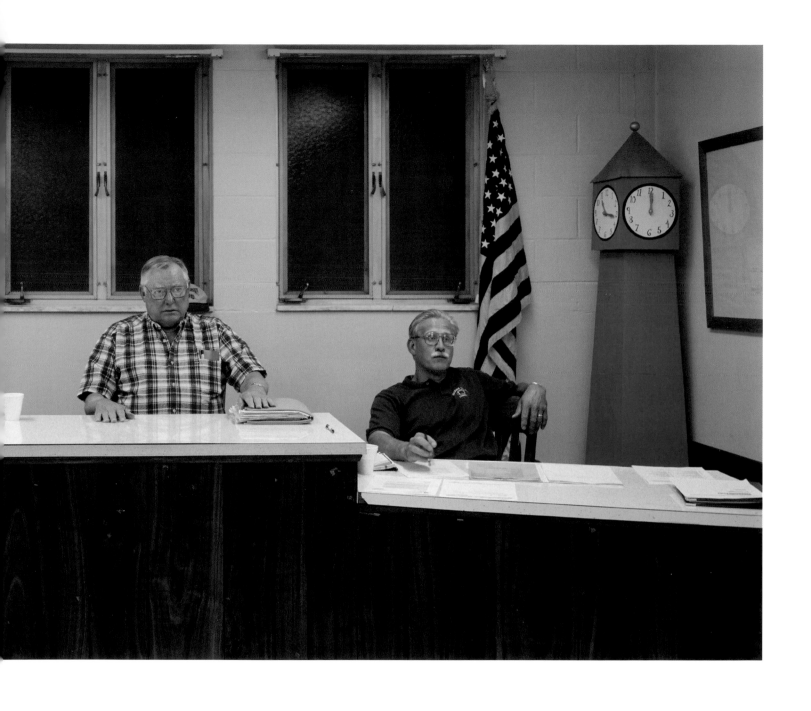

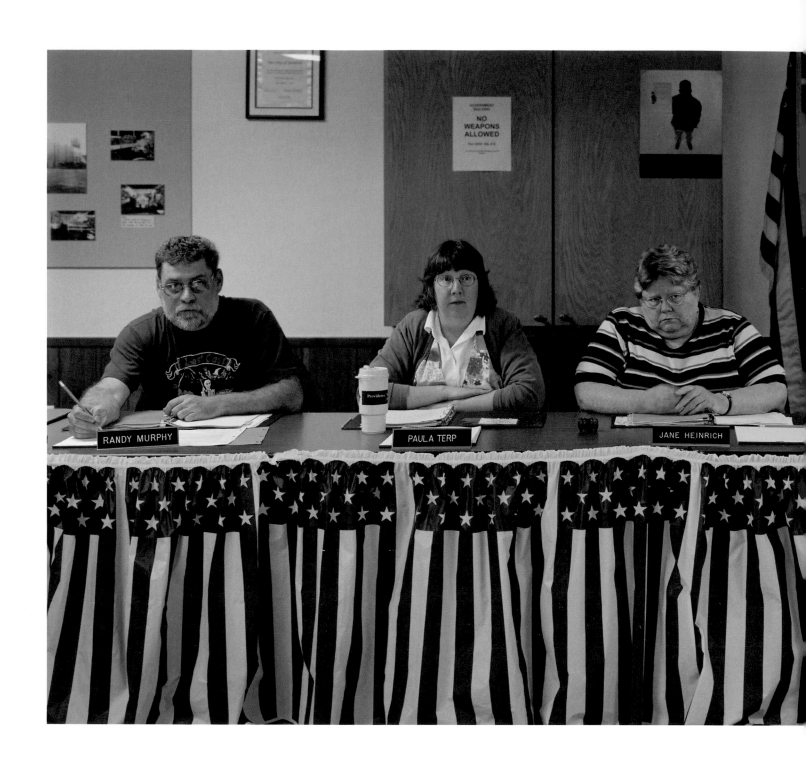

37 Yamhill, Oregon (population 790) City Council, April 9, 2003, 2003. Left to right: Randy Murphy, Paula Terp, Jane Heinrich (mayor), Kay Echauri, Jeff Breazile.

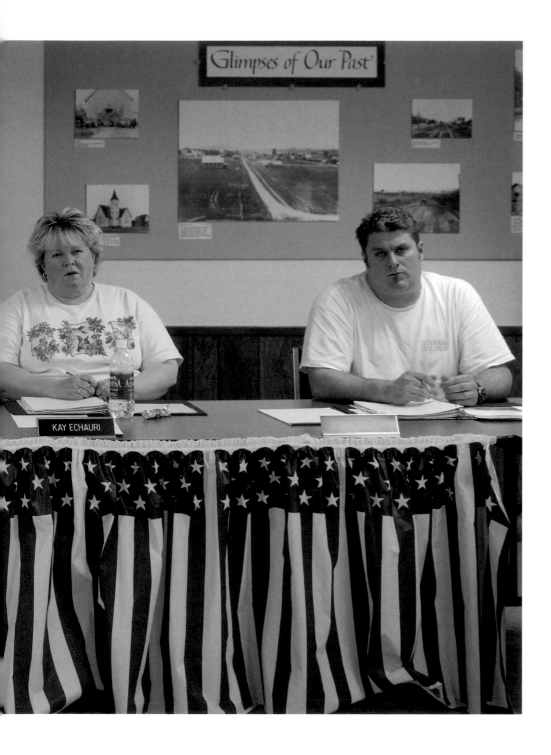

119

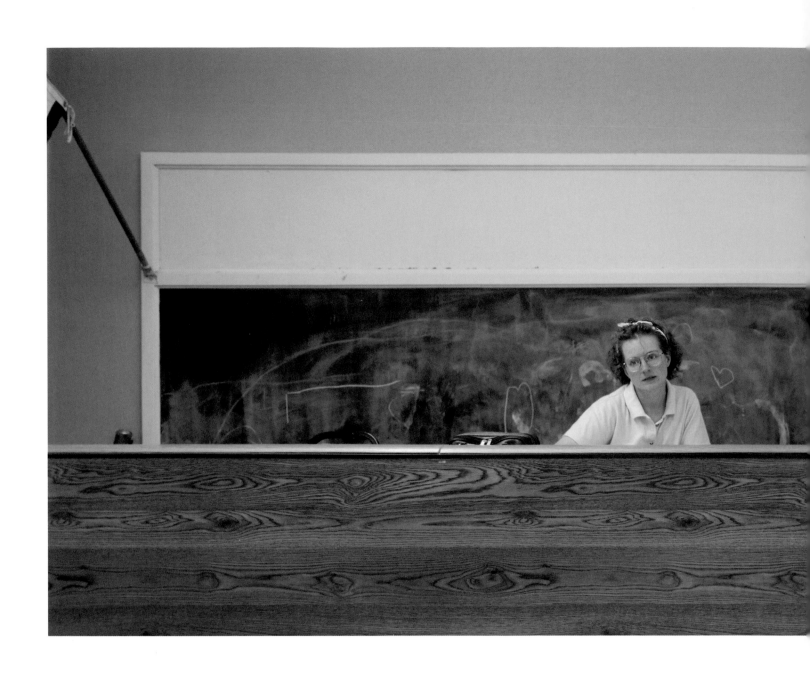

38 <u>Stockton, Utah (population 567) Town Council, June 11, 2001</u>, 2001. Left to right: Angie Harrison, Barry Thomas (mayor), Claudia Baker.

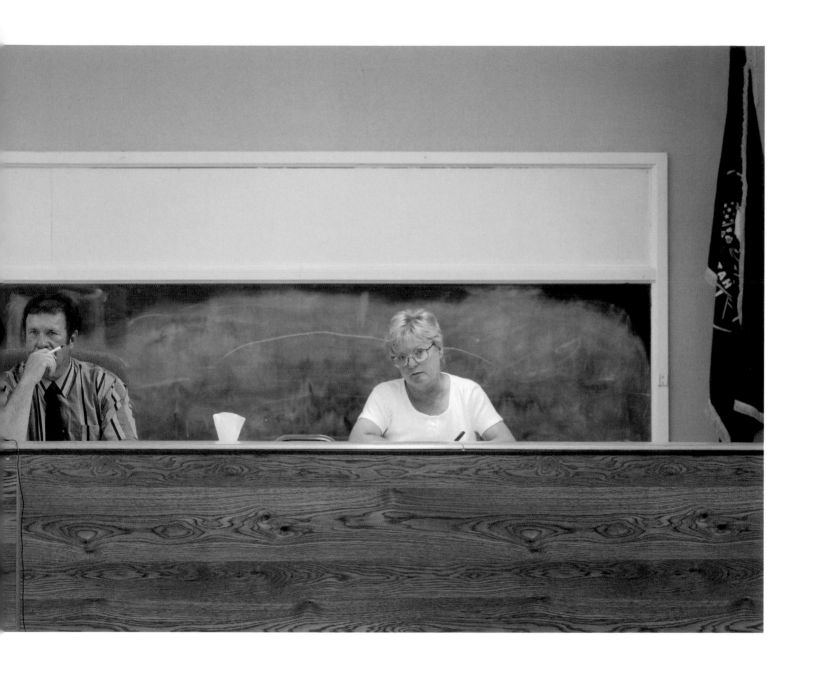

39 Level A Hazmat suit, yellow ("Disaster City" National Emergency Response and Rescue Training Center, Texas Engineering and Extension Service [TEEX], College Station, Texas), 2004

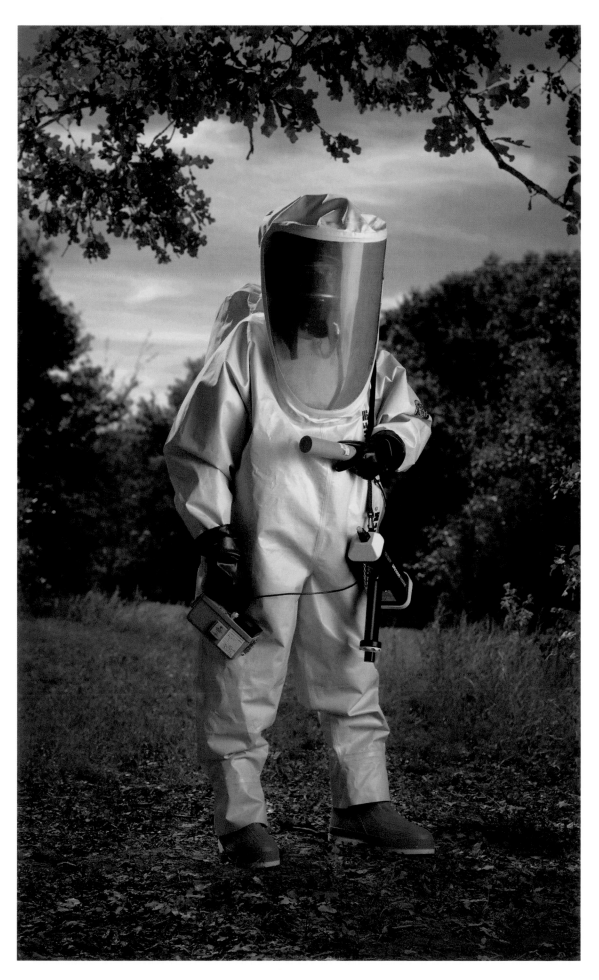

40 <u>Police SWAT, camouflage (Tucson, Arizona, Police Department SWAT, "Terror Town" Playas Training Center, New Mexico)</u>, 2005

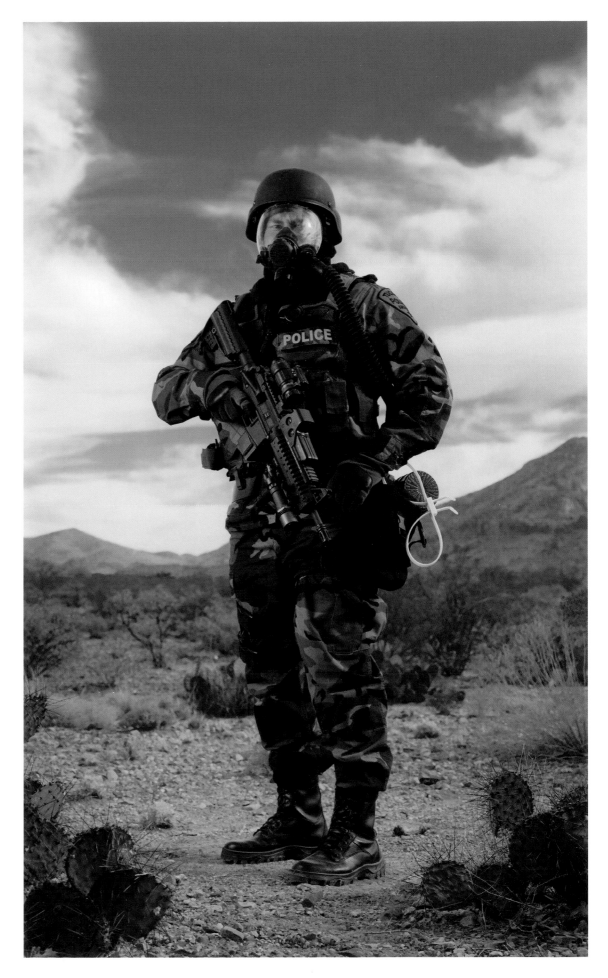

41 Bomb suit, robot (148th Explosive Ordnance Disposal, Minnesota Air National Guard, Duluth, Minnesota), 2005

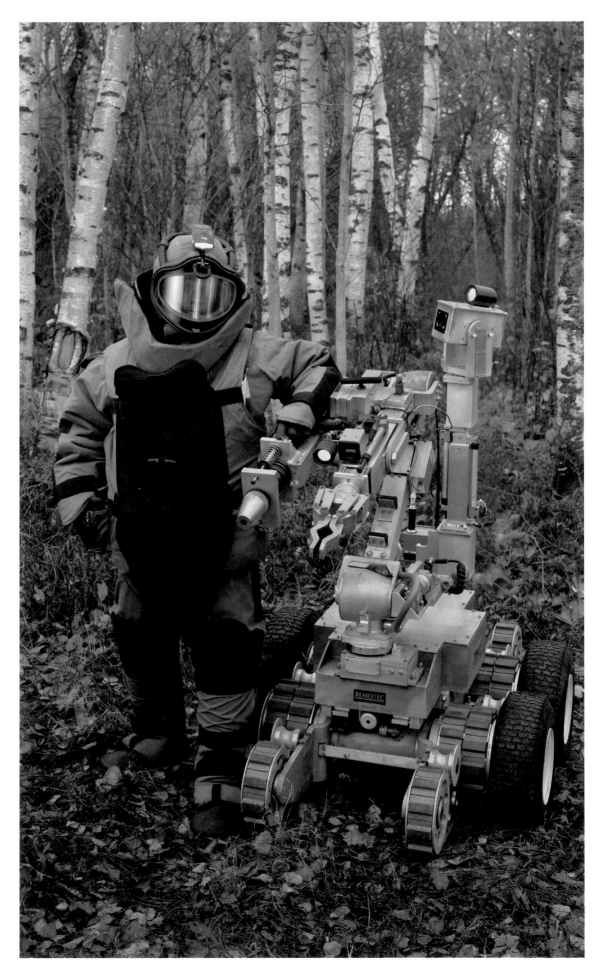

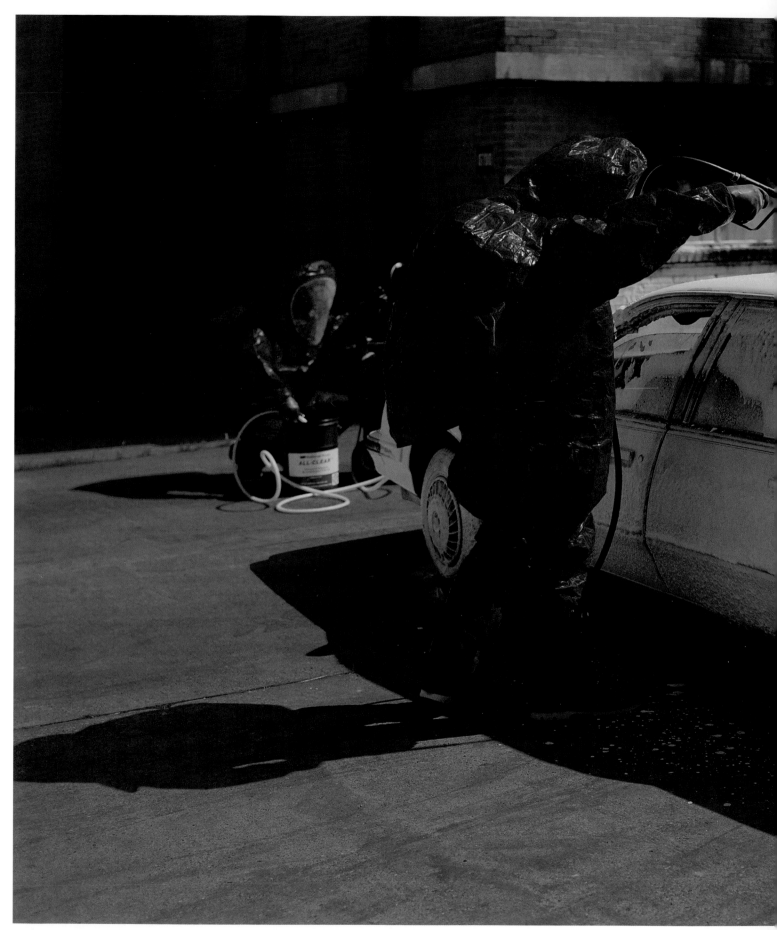

42 Decontamination foam test ("Disaster City" National Emergency Response and Rescue Training Center, Texas Engineering and Extension Service [TEEX], College Station, Texas), 2006

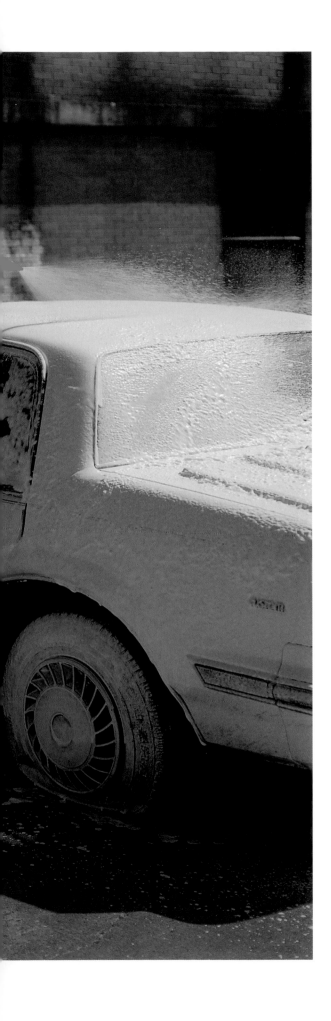

43 <u>Radiation check (National Center for Combating Terrorism, Nevada Test Site)</u>, 2005

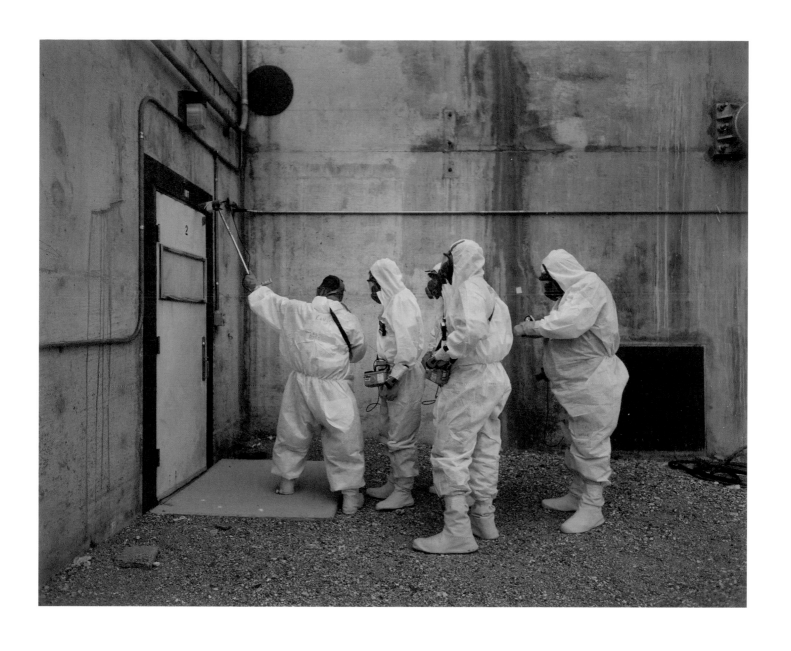

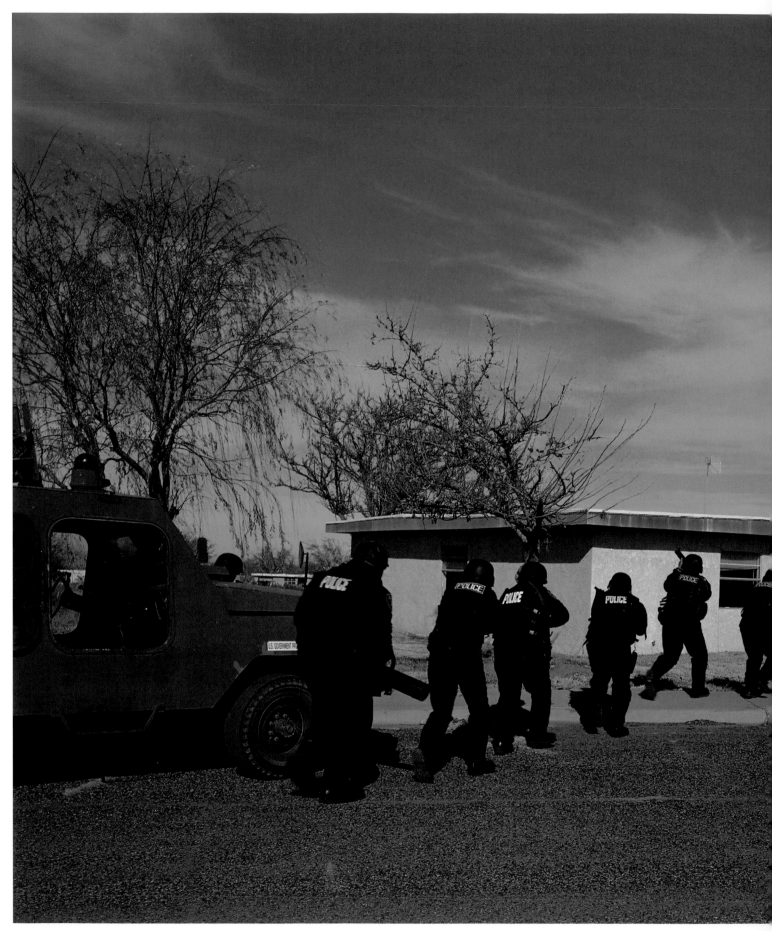

44 SWAT team approaching house (Guam Police Department SWAT, "Terror Town" Playas Training Center, New Mexico), 2005

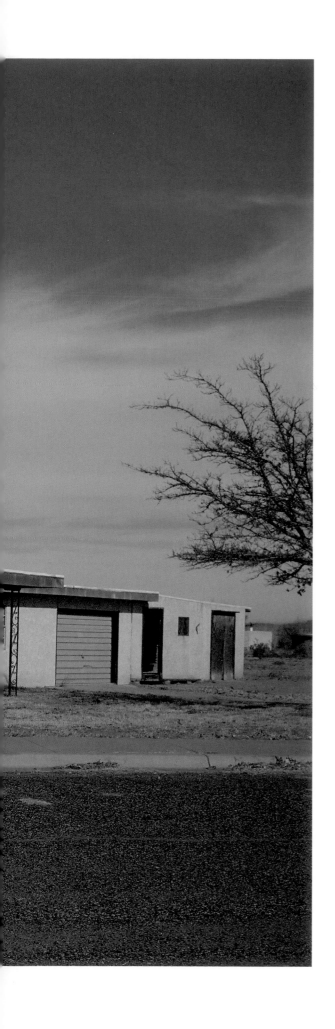

45 <u>Bomb suits on road (Hazardous Devices School, FBI and U.S. Army, Redstone Arsenal, Huntsville, Alabama)</u>, 2007

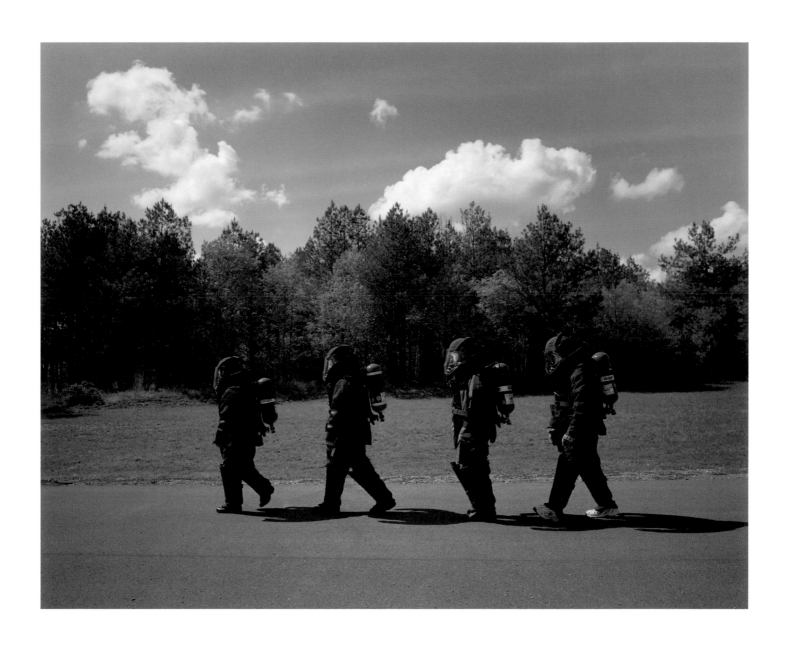

46 <u>Breach ("Terror Town" Playas Training Center, New Mexico)</u>, 2005

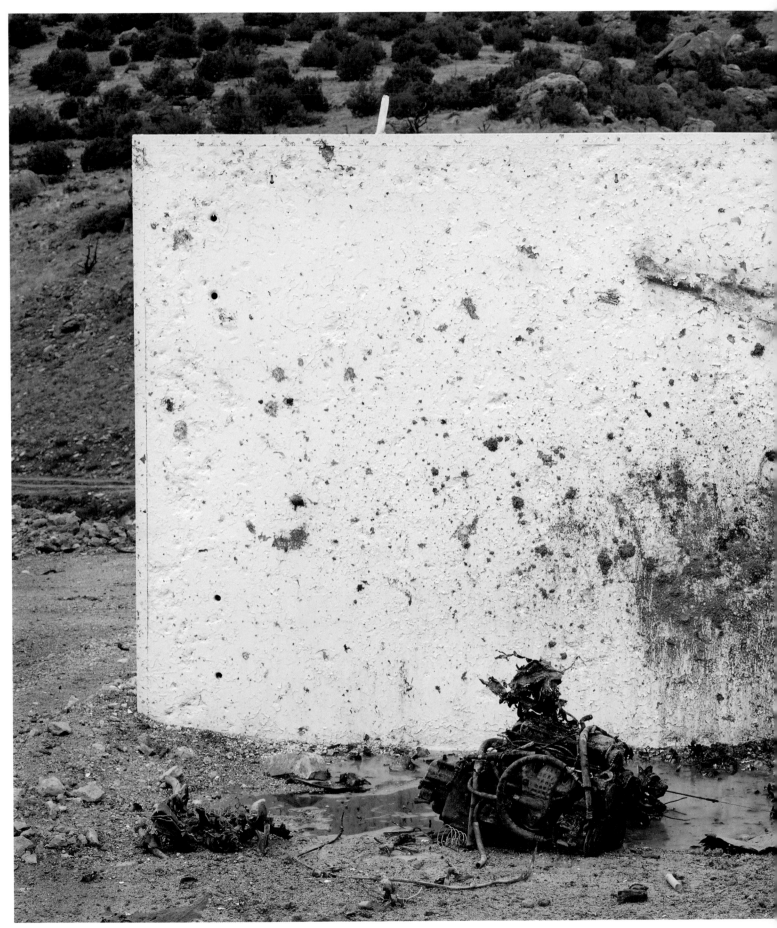

47 1987 Honda Civic, 300 lb ANFO explosive (Energetic Materials Research and Testing Center [EMRTC], New Mexico Tech, Socorro, New Mexico), 2005

EXHIBITION CHECKLIST

Dimensions are in inches; height precedes width.

All works in the exhibition were lent by the artist unless otherwise indicated.

FACTORIES

1
Boeing Company, Everett, Washington (747 aircraft), 1987. Color coupler print, 48 x 61. Courtesy of Anoka Technical College, Anoka, Minnesota, Public Art Commission, 1988.

2
Hughes Aircraft Company, El Segundo, California (Intelsat VI satellite), 1988. Pigmented inkjet on paper, 24 x 30.

3
Valspar Corporation, Minneapolis, Minnesota (paint), 1987. Pigmented inkjet on paper, 24 x 30.

4
Honeywell, Inc., Golden Valley, Minnesota (residential controls), 1986. Pigmented inkjet on paper, 24 x 30.

5
Rockwell International, Palmdale, California (space shuttle orbiter Endeavor), 1988. Color coupler print, 48 x 61. Courtesy of the Artist and the Artist Pension Trust, NY.

6
North Star Steel Company, St. Paul, Minnesota, 1988. Pigmented inkjet on paper, 24 x 30.

7
Badger Foundry Company, Winona, Minnesota (ferrous metal foundry), 1986. Color coupler print, 48 x 61. Courtesy of Anoka Technical College, Anoka, Minnesota, Public Art Commission, 1988.

8
Ford Motor Company, St. Paul, Minnesota (truck assembly), 1986. Pigmented inkjet on paper, 24 x 30.

9
Mentor Corporation, Minneapolis, Minnesota (penile implants), 1988. Pigmented inkjet on paper, 24 x 30.

10
Control Data Corporation, Bloomington, Minnesota (computer disk drives), 1986. Pigmented inkjet on paper, 24 x 30.

OFFICES

11
First Bank System, Inc. (#1), Minneapolis, Minnesota, 1989. Pigmented inkjet on paper, 24 x 30.

12
First Bank System, Inc. (#2), Minneapolis, Minnesota, 1989. Pigmented inkjet on paper, 24 x 30.

13
General Mills, Inc. (#4), Golden Valley, Minnesota, 1989. Color coupler print, 30 x 37.5.

14
Cray Research, Inc. (#3), Minneapolis, Minnesota, 1989. Pigmented inkjet on paper, 24 x 30.

15
General Mills, Inc. (#1), Golden Valley, Minnesota, 1989. Pigmented inkjet on paper, 24 x 30.

16
Honeywell, Inc. (#1), Minneapolis, Minnesota, 1989. Pigmented inkjet on paper, 24 x 30.

17
General Mills, Inc. (#5), Golden Valley, Minnesota, 1989. Pigmented inkjet on paper, 24 x 30.

NUCLEAR WEAPONS

18
B83 one-megaton nuclear gravity bombs in Weapons Storage Area, Barksdale Air Force Base, Louisiana, 1995. Color coupler print, 48 x 61. Courtesy of the Artist and the Artist Pension Trust, NY.

19
Ohio class Trident submarine USS Alaska in dry dock for refit, Naval Submarine Base Bangor, Washington, 1992. Pigmented inkjet on paper, 24 x 30.

20
Trident submarine control room, USS Alaska, Naval Submarine Base Bangor, Washington, 1992. Color coupler print, 48 x 61.

21
Poseidon submarine missile hatches, USS Stonewall Jackson, Naval Submarine Base Kings Bay, Georgia, 1994. Pigmented inkjet on paper, 24 x 30.

22

Nine ICBM silos, 1992 – 2001. Left to right, top to bottom: Minuteman III "Alpha 7," Egbert, Wyoming; Minuteman III "Kilo 5," Dix, Nebraska; Minuteman II "Foxtrot 9," Leesville, Missouri; Minuteman III "India 8," Ross, North Dakota; Minuteman III "Mike 6," Merino, Colorado; Minuteman II "Lima 6," Vale, South Dakota; Minuteman III "Foxtrot 10," Coteau, Montana; Minuteman III "Juliet 8," Peetz, Colorado; Minuteman III "Golf 7," Bowman's Corners, Montana. Pigmented inkjet on paper, 40 x 70.

23

Joint Chiefs of Staff Conference Room, National Military Command Center, the Pentagon, Washington, D.C., 1993. Pigmented inkjet on paper, 24 x 30.

24

Combat Alert Facility for bomber crews, Ellsworth Air Force Base, South Dakota, 1992. Color coupler print, 48 x 61. Courtesy of the Artist and the Artist Pension Trust, NY.

25

Blast door, "November 1" Minuteman II Launch Control Center, Newell, South Dakota, 1992. Pigmented inkjet on paper, 24 x 30.

26

Minuteman II Missile in Transporter Erector Vehicle, Ellsworth Air Force Base, South Dakota, 1992. Color coupler print, 48 x 61.

27

Debris from first stage of unsuccessful Minuteman I missile test launch, Vandenberg Air Force Base, California, 1993. Pigmented inkjet on paper, 24 x 30.

28

Peacekeeper missile test launch preparation, Vandenberg Air Force Base, California, 1993. Pigmented inkjet on paper, 24 x 30.

29

Peacekeeper missile W87/Mk-21 Reentry Vehicles (warheads) in storage, F. E. Warren Air Force Base, Cheyenne, Wyoming, 1992. Pigmented inkjet on paper, 24 x 30.

MEETINGS

30

Dobbins Heights, North Carolina (population 936) Town Council, November 8, 2001, 2001. Left to right: Mary Magee (clerk), Channie McManus, Nell Moody, Christine Davis, Gracie Jackson (mayor pro tem). Pigmented inkjet on canvas with varnish, 24 x 66.

31

Buckland, Massachusetts (population 1,943) Board of Selectmen, July 27, 1999, 1999. Left to right: Kevin P. Fox, John F. Brosnan (chair). Pigmented inkjet on canvas with varnish, 33 x 66. Courtesy of the Artist and the Artist Pension Trust, NY.

32

Maurice, Louisiana (population 642) Village Council, May 15, 2002, 2002. Left to right: Paul Catalon, Lee Wood, Barbara Picard (mayor), Mary Hebert (clerk), Marlene Theriot. Pigmented inkjet on canvas with varnish, 33 x 66.

33

Lee, New Hampshire (population 4,145) Board of Selectmen, January 27, 2003, 2003. Left to right: Dwight Barney (chairman), Joseph Ford, Richard Wellington. Pigmented inkjet on canvas with varnish, 33 x 66.

34

Wadley, Georgia (population 2,468) City Council, August 13, 2001, 2001. Left to right: Izell Mack, Charles Lewis, Albert Samples (mayor), Robert Reeves (city attorney). Pigmented inkjet on canvas with varnish, 33 x 66.

35

Lewiston, Minnesota (population 1,405) City Council, March 10, 1999, 1999. Left to right: Roger Laufenburger (mayor), Denny Engrav, Gary Sauers, Robert Rys (city administrator). Pigmented inkjet on canvas with varnish, 24 x 66. Collection of Minnesota Historical Society.

36

Markle, Indiana (population 1,228) Town Council, July 21, 1999, 1999. Left to right: Wayne Ridgley, Jay Fox (president), Jeff Stockman. Pigmented inkjet on canvas with varnish, 33 x 66.

37

Yamhill, Oregon (population 790) City Council, April 9, 2003, 2003. Left to right: Randy Murphy, Paula Terp, Jane Heinrich (mayor), Kay Echauri, Jeff Breazile. Pigmented inkjet on canvas with varnish, 33 x 66.

38
<u>Stockton, Utah (population 567) Town Council, June 11,</u>
<u>2001</u>, 2001. Left to right: Angie Harrison, Barry Thomas
(mayor), Claudia Baker. Pigmented inkjet on canvas
with varnish, 24 x 66. Collection Walker Art Center,
Minneapolis. Gift of Richard Flood, 2005.

SECURITY

39
<u>Level A Hazmat suit, yellow ("Disaster City" National</u>
<u>Emergency Response and Rescue Training Center,</u>
<u>Texas Engineering and Extension Service [TEEX],</u>
<u>College Station, Texas)</u>, 2004. Pigmented inkjet on
canvas with varnish, 63 x 38. Courtesy of the Artist and
the Artist Pension Trust, NY.

40
<u>Police SWAT, camouflage (Tucson, Arizona, Police</u>
<u>Department SWAT, "Terror Town" Playas Training Center,</u>
<u>New Mexico)</u>, 2005. Pigmented inkjet on canvas with
varnish, 63 x 38.

41
<u>Bomb suit, robot (148th Explosive Ordnance Disposal,</u>
<u>Minnesota Air National Guard, Duluth, Minnesota)</u>,
2005. Pigmented inkjet on canvas with varnish, 63 x 38.

42
<u>Decontamination foam test ("Disaster City" National</u>
<u>Emergency Response and Rescue Training Center,</u>
<u>Texas Engineering and Extension Service [TEEX],</u>
<u>College Station, Texas)</u>, 2006. Pigmented inkjet on
paper, 24 x 30.

43
<u>Radiation check (National Center for Combating</u>
<u>Terrorism, Nevada Test Si</u>te), 2005. Pigmented inkjet on
paper, 24 x 30.

44
<u>SWAT team approaching house (Guam Police</u>
<u>Department SWAT, "Terror Town" Playas Training Center,</u>
<u>New Mexico)</u>, 2005. Pigmented inkjet on paper, 24 x 30.

45
<u>Bomb suits on road (Hazardous Devices School, FBI</u>
<u>and U.S. Army, Redstone Arsenal, Huntsville, Alabama)</u>,
2007. Pigmented inkjet on paper, 24 x 30.

46
<u>Breach ("Terror Town" Playas Training Center, New</u>
<u>Mexico)</u>, 2005. Diptych. Pigmented inkjet on paper, each
panel 20 x 20.

47
<u>1987 Honda Civic, 300 lb ANFO explosive (Energetic</u>
<u>Materials Research and Testing Center [EMRTC], New</u>
<u>Mexico Tech, Socorro, New Mexico)</u>, 2005. Pigmented
inkjet on paper, 42 x 63. Courtesy of the Artist and the
Artist Pension Trust, NY.

PAUL SHAMBROOM

Paul Shambroom's photography explores American power and culture. His series-based color photographs reveal both local and global manifestations of power, depicting scenes in industrial, business, community, and military environments. Extensive research and complicated logistics frequently characterize his projects. Two of Paul's series have been the subjects of books: Face to Face with the Bomb: Nuclear Reality after the Cold War (2003), based on Nuclear Weapons, and Meetings (2004). His current project, Security, documents official U.S. government preparedness and training in the aftermath of 9/11.

Paul's photographs have been collected and exhibited by many museums, including the Whitney Museum of American Art, the Museum of Modern Art (New York), the San Francisco Museum of Modern Art, the Los Angeles County Museum of Art, the Art Institute of Chicago, and the Walker Art Center. He has had solo exhibitions at the Walker Art Center, the Museum of Contemporary Photography in Chicago, Les Rencontres d'Arles Photographie in France, the Nederlands Fotomuseum, Julie Saul Gallery, New York, and Stephen Wirtz Gallery, San Francisco. His work was selected for the 1997 Whitney Biennial at the Whitney Museum of American Art. He has received fellowships from the Guggenheim Foundation, the Creative Capital Foundation, the Penny McCall Foundation, the Jerome Foundation, the McKnight Foundation, the Bush Foundation, and the Minnesota State Arts Board.

Paul was born in Teaneck, New Jersey, in 1956. He studied liberal arts at Macalester College in St. Paul, Minnesota, and received a BFA from the Minneapolis College of Art and Design. He lives and works in Minneapolis.

EXHIBITION HISTORY

SOLO EXHIBITIONS

2008 – 9

Paul Shambroom: Picturing Power, Weisman Art Museum, Minneapolis, Minnesota; Columbus Museum of Art, Columbus, Ohio; Atlanta Contemporary Art Center, Atlanta, Georgia; University Art Museum, California State University, Long Beach, California

Stephen Wirtz Gallery, San Francisco

2007

Paul Shambroom: Security, Kavi Gupta Gallery, Chicago, Illinois

2006

Hereford Photography Festival, Hereford, England

Security, Julie Saul Gallery, New York, New York

Security, Weinstein Gallery, Minneapolis, Minnesota

2005

Face to Face with the Bomb, Atomic Testing Museum, Las Vegas, Nevada

Meetings, Rocket Gallery, London, England

Meetings, Fotografie Forum International, Frankfurt, Germany

Meetings, Howard Yezerski Gallery, Boston, Massachusetts

Nuclear Weapons, Nederlands Fotomuseum, Rotterdam, Netherlands (shown with Michael Light's 100 Suns)

2004

Paul Shambroom: Meetings, Hordaland Kunstsenter, Bergen, Norway

More Meetings, Julie Saul Gallery, New York, New York

Meetings, Les Rencontres d'Arles Photographie, Arles, France

2003

Evidence of Democracy: Paul Shambroom, Museum of Contemporary Photography, Chicago, Illinois

Paul Shambroom, Le Mois de la Photo à Montréal, Montreal, Quebec, Canada

2002

Paul Shambroom: Meetings, Julie Saul Gallery, New York, New York

2001

Paul Shambroom: Meetings, Franklin Art Works, Minneapolis, Minnesota

1998

Paul Shambroom, Tanya Bonakdar Gallery, New York, New York

1995

Paul Shambroom: Hidden Places of Power, Walker Art Center, Minneapolis, Minnesota

Face to Face with the Bomb, CEPA Gallery, Buffalo, New York; Medaille College, Buffalo, New York

1991

Childhood, Bockley Gallery, Minneapolis, Minnesota

1990

Workplace Interiors, Bockley Gallery, Minneapolis, Minnesota

1984

Portrait of Hennepin Avenue, Minnesota Historical Society, St. Paul, Minnesota

1979

Large Color Photographs, Film in the Cities, St. Paul, Minnesota

Portrait of Hennepin Avenue, Hennepin Center for the Arts, Minneapolis, Minnesota

GROUP EXHIBITIONS

2008 – 11

The Nuclear Dilemma, International Red Cross and Red Crescent Museum, Geneva, Switzerland; Gernika Peace Museum, Guernica, Spain

2007

Loaded Landscapes, Museum of Contemporary Photography, Chicago, Illinois

The BIG Picture, North Carolina Museum of Art, Raleigh, North Carolina

John Q. Public & Citizen Jane: Private Americans in the Public Domain, University Art Gallery, San Diego State University, San Diego, California

Critical Translations, Katherine E. Nash Gallery, University of Minnesota, Minneapolis, Minnesota

2006

The Office/In and Out of the Box, Dorsky Gallery, Long Island City, Queens, New York

Bunch Alliance and Dissolve, Contemporary Arts Center Cincinnati, Cincinnati, Ohio

MMoCA Collects, Madison Museum of Contemporary Art, Madison, Wisconsin

2005

Regarding the Rural, Massachusetts Museum of Contemporary Art, North Adams, Massachusetts

In Focus: Contemporary Photography from the Allen G. Thomas Jr. Collection, North Carolina Museum of Art, Raleigh, North Carolina

Rite of Assembly, Weinstein Gallery, Minneapolis, Minnesota

2004

Shifting the Political: Portraits of Power, Center for Photography at Woodstock, Woodstock, New York

About Face: Photographic Portraits from the Collection, Art Institute of Chicago, Chicago, Illinois

Artists Interrogate: Politics and War, Milwaukee Art Museum, Milwaukee, Wisconsin

Inside Out: Portrait Photographs from the Permanent Collection, Whitney Museum of American Art, New York, New York

2003

Pictures from Within: American Photographs, 1958 – 2003, Whitney Museum of American Art, New York, New York

American Dream, Ronald Feldman Gallery, New York, New York

2003 – 4

Social Strategies: Redefining Social Realism, University Art Museum, University of California Santa Barbara, Santa Barbara, California; University Galleries, Illinois State University, Normal, Illinois; Richard E. Peeler Art Center, DePauw University, Greencastle, Indiana; Schick Art Gallery, Skidmore College, Saratoga Springs,

New York; Newcomb Art Gallery, Tulane University, New Orleans, Louisiana

2002 – 4

The View from Here: Recent Pictures from Central Europe and the American Midwest, Ludwig Museum, Budapest, Hungary; City Gallery Prague, Prague, Czech Republic; The Riffe Gallery, Columbus, Ohio; SPACES, Cleveland, Ohio; Minnesota Center for Photography, Minneapolis, Minnesota; Erie Art Museum, Erie, Pennsylvania

2001 – 5

American Tableaux: Selections from the Collection of the Walker Art Center, Walker Art Center, Minneapolis, Minnesota; Miami Art Museum, Miami, Florida; Delaware Art Museum, Wilmington, Delaware; University of Iowa Museum of Art, Iowa City, Iowa; Winnipeg Art Gallery, Winnipeg, Manitoba, Canada; Plains Art Museum, Fargo, North Dakota

2001 – 2

The Atomic Photographers Guild: Visibility and Invisibility in the Nuclear Era, Gallery Toronto Photographers Workshop, Toronto, Ontario, Canada

2001

ExtraOrdinary: American Place in Recent Photography, Madison Art Center, Madison, Wisconsin

1999

Photography from the Martin Z. Margulies Collection, Florida International University Art Museum, Miami, Florida

Persuasion, Lombard-Freid Gallery, New York, New York

1997

Whitney Biennial, Whitney Museum of American Art, New York, New York

Summer of Love, Fotouhi Cramer Gallery, New York, New York

1996

Crossing the Frontier: Photographs of the Developing West, 1849 to the Present, San Francisco Museum of Modern Art, San Francisco, California

Truth and Trials: Color Photography since 1975, Minneapolis Institute of Arts, Minneapolis, Minnesota

McKnight Fellowship Recipients, Katherine E. Nash Gallery, University of Minnesota, Minneapolis, Minnesota

1995

In the Shadow of the Cloud, Portland Art Museum, Portland, Oregon

1994

Local Color: Recent Photographic Works, pARTS Gallery, Minneapolis, Minnesota

10th Anniversary Show, Bockley Gallery, Minneapolis, Minnesota

1993

Recent Acquisitions in Photography, Museum of Modern Art, New York, New York

1990

Recent Accessions, 1984-1990, Minneapolis Institute of Arts, Minneapolis, Minnesota

McKnight Fellowship Recipients, Film in the Cities, St. Paul, Minnesota

1988

Five Jerome Artists, Minneapolis College of Art and Design, Minneapolis, Minnesota

1986

McKnight Fellowship Recipients, Film in the Cities, St. Paul, Minnesota

Young Minnesota Artists, University Gallery, University of Minnesota, Minneapolis, Minnesota

1982

Young Minnesota Artists, University Gallery, University of Minnesota, Minneapolis, Minnesota

1981

Color Photography, Forecast Alternative Art Spaces, Minneapolis, Minnesota

1979 – 81

International Self-Portrait Invitational, Northlight Gallery, Arizona State University, Tempe, Arizona

1978

How I Spent My Summer Vacation, SF Camerawork, San Francisco, California

REPRODUCTION CREDITS

Reproductions of photography by Paul Shambroom are printed courtesy of the artist. We also acknowledge the following lenders to the exhibition: Walker Art Center (Plates 26, 38); Minnesota Historical Society (Plate 35); Anoka Technical College (Plates 1, 7); and Artist Pension Trust (Plates 5, 18, 24, 31, 39, 47).

Letters, records, and research materials belonging to Paul Shambroom are reproduced courtesy of the artist.

Photograph of William Shambroom by Diane Arbus from Show magazine, September 1962. Courtesy of Paul Shambroom.

Bernd and Hilla Becher, Wassertürme (Water Towers), 1972. Collection Walker Art Center, Minneapolis. Justin Smith Purchase Fund, 1996.

Christo and Jeanne-Claude, Wrapped Reichstag, 1972 – 95, Berlin. Photograph by Wolfgang Volz. Copyright Christo 1995.

Walker Evans, Bud Fields and His Family at Their Home in Alabama, 1935, 1936. Collection of the Frederick R. Weisman Art Museum at the University of Minnesota, Minneapolis. Museum purchase.

Lee Friedlander, Canton, Ohio, from Factory Valleys series, 1980. Courtesy of Fraenkel Gallery, San Francisco.

Lee Friedlander, Cleveland, Ohio, from Factory Valleys series, 1980. Courtesy of Fraenkel Gallery, San Francisco.

Thomas Gainsborough, Mr. and Mrs. Andrews, 1750. National Gallery, London. Bought with contributions from the Pilgrim Trust, the National Art Collections Fund, Associated Television Ltd., and Mr. and Mrs. W. W. Spooner, 1960. Copyright The National Gallery, London.

Lewis Hine, Young Boy Coal Miner, 1909 – 13. Collection of the Frederick R. Weisman Art Museum at the University of Minnesota, Minneapolis. Gift of the Scandinavian Language Department, University of Minnesota.

Douglas Huebler, Variable Piece No. 70 (in Process), May 10, 1976, 1976. National Gallery of Canada, Ottawa. Photograph copyright National Gallery of Canada.

Dorothea Lange, Migrant Mother, Nipomo, California, 1936. Minneapolis Institute of Arts, The Alfred and Ingrid Lenz Harrison Fund.

Leonardo da Vinci, The Last Supper, 1498. Postrestoration. S. Maria delle Grazie, Milan, Italy. Copyright Scala / Art Resource, New York.

László Moholy-Nagy, Nuclear II, 1946. Milwaukee Art Museum. Gift of Kenneth Parker [M1970.110]. Photography by P. Richard Eells.

James Rosenquist, F-111, 1964 – 65. The Museum of Modern Art, New York. Purchase Gift of Mr. and Mrs. Alex L. Hillman and Lillie P. Bliss Bequest (both by exchange) (00473.96.a-w). Photograph: Digital Image copyright The Museum of Modern Art. Licensed by SCALA / Art Resource, New York. Copyright James Rosenquist. Licensed by VAGA, New York, New York.

Martha Rosler, from The Bowery in Two Inadequate Descriptive Systems, 1974 – 75. Courtesy of the artist.

Steve Rowell, Playas sits and waits for its day in the sun, 2005. Center for Land Use Interpretation.

Robert Smithson, Monuments of Passaic (The Bridge Monument Showing Wooden Sidewalk), 1967. Instamatic snapshot by Robert Smithson. Collection of The National Museum of Contemporary Art Oslo, Oslo, Norway. Copyright Estate of Robert Smithson. Licensed by VAGA, New York, New York. Image courtesy James Cohan Gallery, New York.